D1268820

The Surreal Body

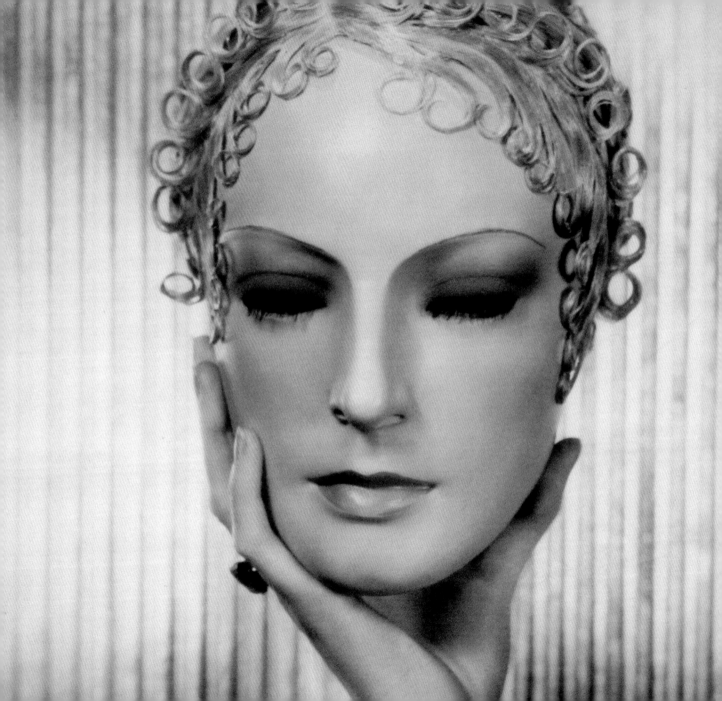

The Surreal Body

Fetish and Fashion

Ghislaine Wood

V&A Publications

Acknowledgements

For Ben

With thanks to
Alexander Klar,
Juliette Hibou,
Maria Mileeva, Dilys
Blum, Alyce Mahon,
Ingrid Schaffner, Judith
Mallin, Mark Walsh,
Richard Overstreet,
Monica Woods,
Rachel Connolly,
Julia Woollams, and
many others.

First published by V&A Publications, 2007
V&A Publications
Victoria and Albert Museum
South Kensington
London SW7 2RL

Distributed in North America by Harry N. Abrams, Inc.,
New York

© The Board of Trustees of the Victoria and Albert Museum, 2007

The moral right of the author has been asserted.

ISBN 978 1 85177 502 6
Library of Congress Control Number 2006936572

10 9 8 7 6 5 4 3 2 1
2011 2010 2009 2008 2007

A catalogue record for this book is available from
the British Library.

All rights reserved. No part of this publication may be
reproduced, stored in a retrieval system, or transmitted in
any form or by any means electronic, mechanical,
photocopying, recording or otherwise, without written
permission of the publishers.

Every effort has been made to seek permission to reproduce
those images whose copyright does not reside with the V&A,
and we are grateful to the individuals and institutions who have
assisted in this task. Any omissions are entirely unintentional,
and the details should be addressed to V&A Publications.

Designed by johnson banks

New V&A photography by Christine Smith,
V&A Photographic Studio

Jacket design by johnson banks

Frontispiece: George Hoyningen-Huene, Untitled, detail.
Photograph published in *Vogue*, 1932. Collection Bischofberger

Printed in China

V&A Publications
Victoria and Albert Museum
South Kensington
London SW7 2RL
www.vam.ac.uk

Contents

06 Introduction

10 **The Mannequin**
18 Pavillon de l'Élégance
26 Mannequin Street

32 **The Fetish**

42 **Bodies Transformed: Surrealist Women**

56 **The Shop Window**

62 **Surreal Fashion**

82 **Dalí's Jewels**

86 **The Dream of Venus**

92 Notes
93 Further Reading
95 Index
96 Picture Credits

Introduction

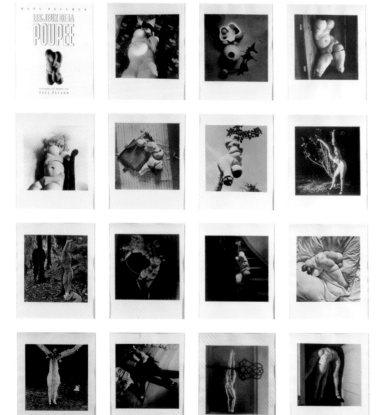

The representation of the body, and particularly the female body, provides a common thread through the public displays, exhibitions and commercial activities of the Surrealists. The body was a site for Surrealist experiment and a conduit for the transmission of ideas. It became the subject of intense scrutiny: dismembered, fragmented, desecrated, eroticized and eulogized in the pursuit of a range of psychological, sociological and sexual concerns. These processes were iterated in mind and physical act. For instance, Hans Bellmer pulled mannequins apart to create violent new forms, while Raoul Ubac submitted 'the image of the body to assaults of a chemical and optical kind'.[1] His complex photomontages were massacres enacted in light and shadow. Above all, the body was a universal, uniting the spheres of the psychological and physical and allowing for an exploration of sexuality as an aspect of modernity.

Importantly, the body also proved the primary agent in the commodification and consumption of Surrealism. Fashion brought it into a direct relationship with commodities, and through the imagery of fashion and fashion photography it was manipulated, fetishized and irrecoverably changed. The mechanisms of fashion promotion –

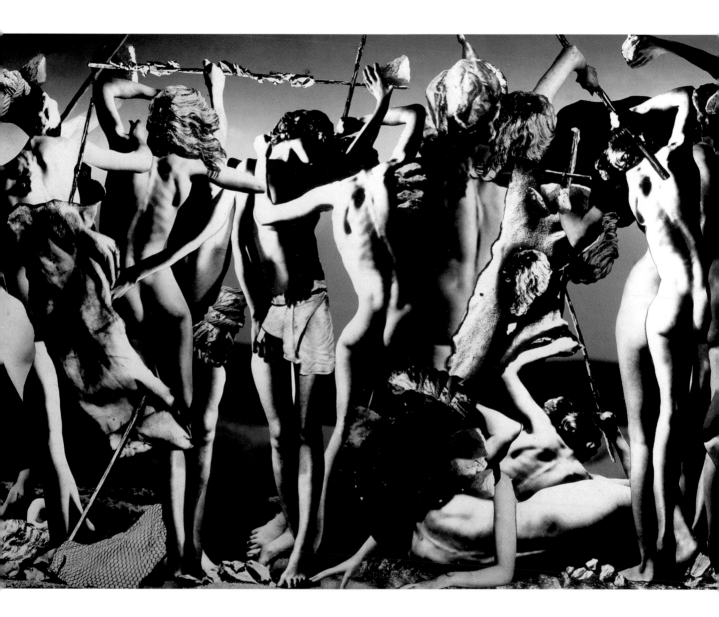

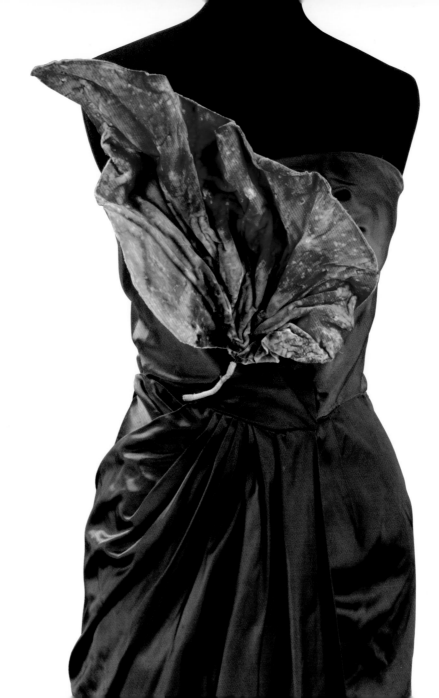

Introduction

shop windows, exhibitions and advertising – ensured that this new surreal vision of the body gained general currency.

Guillaume Apollinaire, a leading advocate of the forms of modernity that most interested the Surrealists, presciently foretold that fashion would eventually assume the mantle of the surreal:

> I have seen a young woman on
> the boulevard dress in tiny mirrors
> that are appliquéd to the fabric.
> In sunlight the effect was dazzling.
> It was like a walking gold mine.
> Later, it began to rain and the lady
> looked like a silver mine. Nutshells
> make pretty pendants, especially if
> one alternates them with hazel-nuts.
> Gowns embroidered with coffee
> beans, cloves, garlic, onions,
> and bunches of dried grapes will
> continue to be fashionable for
> formal wear. Fashion becomes
> practical, scorns nothing and enobles
> everything. It does for substances
> what the romantics did for words.[2]

He could almost be describing the surreal fashions created by Elsa Schiaparelli in the mid 1930s. Schiaparelli utilized extraordinary materials and raided the imagery of Surrealism in pursuit of a modernity inflected with humour, surprise and a sense of the bizarre.

In both Surrealism and fashion the body was woven in fantasy and literally reimagined.

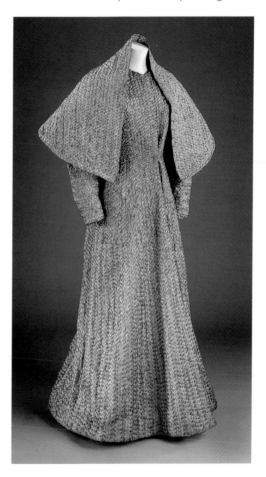

Previous page left: Hans Bellmer, *Les jeux de la poupée.* Portfolio of 15 hand-coloured gelatin silver prints, printed paper and board. 1949. Museum Boijmans Van Beuningen, Rotterdam

Previous page right: Raoul Ubac, *Penthésilée.* Gelatin silver print. 1937. Galerie Natalie et Léon Seroussi, Paris

Opposite: Elsa Schiaparelli, Evening dress. Velvet and silk. 1949. Mark Walsh Leslie Chin

Left: Elsa Schiaparelli, Coat. Gilded copper braid. *c.*1938. V&A: T.235–1976

The Mannequin

'On the orb of the eye, the grand
mannequin glides in a robe of
milky way'[3]
Dictionnaire Abrégé du Surréalisme,
René Crevel

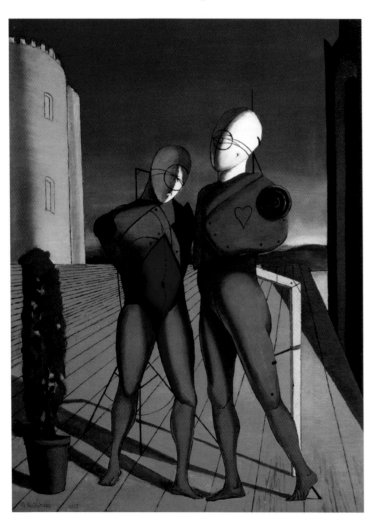

For the Surrealists, the mannequin embodied
the dialectics of modern life. It confused the
boundaries between animate and inanimate,
human and machine, male and female,
the sexualized and the sexless, and ultimately
life and death. It was simultaneously a
commodity, a simulacra, an erotic object,
and the embodiment of the uncanny. For
Freud, the uncanniest objects were 'wax-work
figures, artificial dolls and automatons', and
in the Freudian uncanny the mannequin also
represented the return of a suppressed
elementary or primal human emerging from
the unconscious.[4] For André Breton, the
mannequin was therefore the ultimate
representative of 'convulsive beauty'.

Giorgio de Chirico's haunting images of
mannequins combined the seductive and the
melancholic and fascinated the Surrealists from
the inception of the movement in 1924. These
mysterious images, eulogized by Apollinaire as
archetypally modern, represented the human
form as a commodity and provoked a sense
of 'the crossing of the human and the non

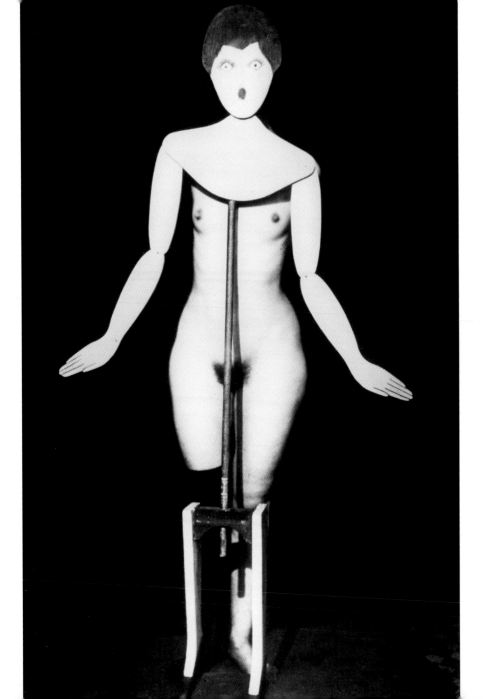

Opposite: Giorgio de Chirico, *Le Duo (les mannequins de la tour rose)*. Oil on canvas. 1915. The Museum of Modern Art, New York

Left: Man Ray, Coat stand. Bromide print on photographic paper. 1920/1975. Museum Boijmans Van Beuningen, Rotterdam

The Mannequin

human'.[5] In *Le Duo* of 1914–15, two
mannequins strike postures in a simulacrum of
a couple. The female, head tilted in deference,
is smaller than the male figure, although both
mannequins are at once male and sexless.
The sensation of a romantic narrative is,
however, accentuated by the heart inscribed
on the chest of the larger dummy. De Chirico's
mannequins, both disturbing and strangely
familiar, provided a model for the Surrealist
imagery of the mannequin that followed.

Freud's first examination of the uncanny,
in E.T.A. Hoffman's early nineteenth-century
story 'The Sandman', which sees the
dismembering of the doll Olympia, provided,
by way of an opera adaptation, the inspiration
for Bellmer's first *Poupée*. The confusion
between life and death embodied in the
mannequin, that so fascinated the Surrealists,
especially obsessed Bellmer. *Poupée* was
first published in the Surrealist journal
Minotaure in 1934, and with its overtones
of misogyny, paedophilia and violence,
it shifted the mannequin imagery onto
new ground.

Bellmer's imagery recalls Joris Karl
Huysmans' *Croquis Parisiens* of 1886, in
which he describes the sensations evoked
on entering a mannequin shop: 'one first
impression is of a morgue where the torsos

Opposite: Man Ray,
La Volière (The Aviary).
Airbrushed gouache,
pencil, pen and ink on
cardboard. 1919.
National Gallery of
Modern Art, Scotland

Left: Hans Bellmer,
La Poupée (The Doll).
Gelatin silver print.
1938. Museum Boijmans
Van Beuningen,
Rotterdam

The Mannequin

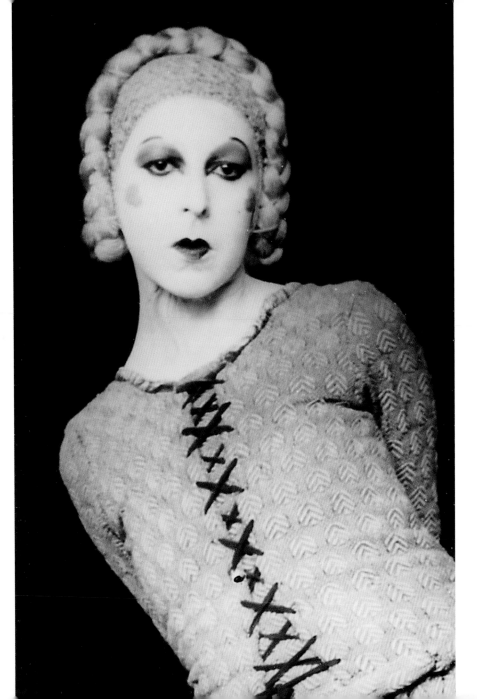

Opposite: Herbert Bayer,
Self-portrait. Gelatin silver
print. 1932. V&A:
Circ.651–1969

Left: Claude Cahun,
Self-portrait. Gelatin silver
print. 1929. Museum
Boijmans Van Beuningen,
Rotterdam

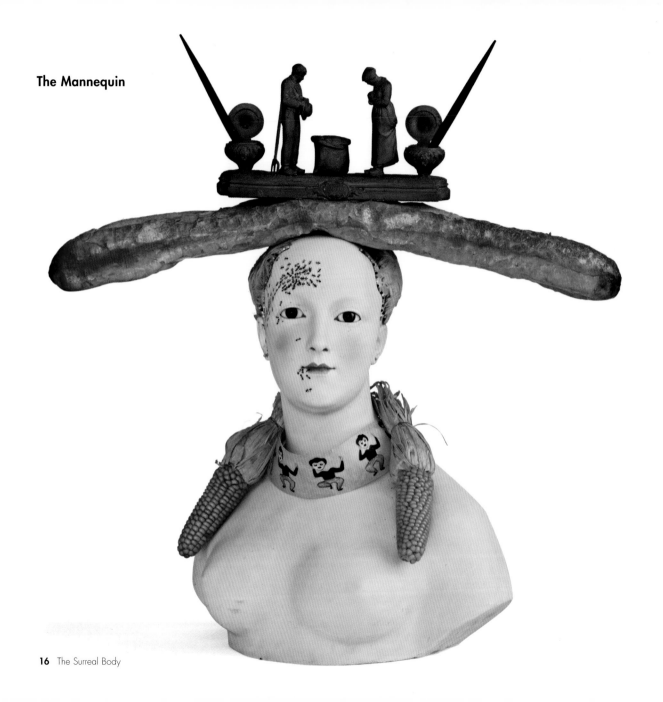

of beheaded corpses are standing upright;
but the horror of these amputated bodies
soon wears off and gives way to suggestive
reflections, for that subsidiary female charm,
the breast, is on display, faithfully reproduced
by the perfect dressmaker who built these
busts'. The text continues with a reverie on the
mannequin breast which becomes a substitute
for real flesh. It is prescient for its identification
of various themes central to the Surrealist
exploration of the mannequin, particularly
death, dismemberment and fetishization.

Several artists incorporated mannequins
or mannequin parts into their work. Bellmer's
Poupée evolved into three-dimensional
composite dolls – perhaps even more disturbing
in their physical three-dimensional presence.
Salvador Dalí created *Retrospective Bust of
a Woman*, which used a porcelain bust as
the basis of the work, while Marcel Jean
covered a cast of Houdon's bust of Madame
Dubarry with black wool and replaced the
eyelids with zips. The zips could be opened
to reveal miniature photographs of a star and
a face. Jean wrapped a reel of film around
the neck, which was to contain footage of an
old film he found in the flea market, called
Le secret du gardénia, later transformed by a
misprint. A disturbing composite object made
of the junk created by the consumer economy,

Opposite: Salvador Dalí,
*Retrospective Bust of a
Woman*. Painted
porcelain, bread, corn,
feathers, paint on paper.
1933. The Museum of
Modern Art, New York

Left: Marcel Jean,
Le spectre du gardénia
(The Spectre of
Gardenia). Plaster
head with painted black
cloth, zips, and strip of
film on velvet-covered
wood base. 1936–71.
Private Collection, Turin

the '*Spectre*' seems to illustrate Hal Foster's
observation that for the Surrealists, the
mannequin embodied 'a modernization that
is also ruinous'.[6]

Pavillon de l'Élégance

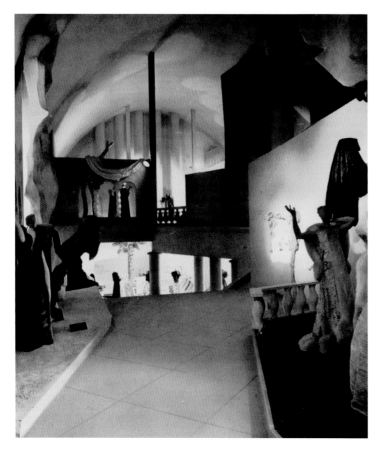

The Pavillon de l'Élégance at the *Exposition Internationale des Arts et Techniques dans la Vie Moderne de Paris* of 1937 was clearly identified as a Surrealist experience. The *London Bystander* described it as 'the crystallization of Surrealism'[7], while the critic Raymond Isay, writing in La Revue des Deux Mondes, noted, in a style laced with Surrealist language, that 'Nowhere else in the exhibition, was the intimate poetic of our era expressed more freely. Many people blame and condemn. However, this Pavillon de l'Élégance only strove to be a workshop of hallucinations, a studio of fantasy, a laboratory of reverie, a dream of our time.'[8]

Designed by Emile Aillaud, Etienne Kohlmann and Max Vibert, the split level space broke away from the conventions of glass cases and static mannequins to create a deeply theatrical and unsettling atmosphere. Employing the illusionistic and Surrealist qualities of plaster, they succeeded in creating an extraordinary experience. Marcel Jean later observed, 'the statue of a lion was decorated with a mane in bright red fur. The sense of disorientation obtained by means of an exteriorized, formal novelty, ephemeral but charming.'[9]

By far the most dramatic elements were the giant mannequins designed by the sculptor Robert Couturier. These figures, many of them

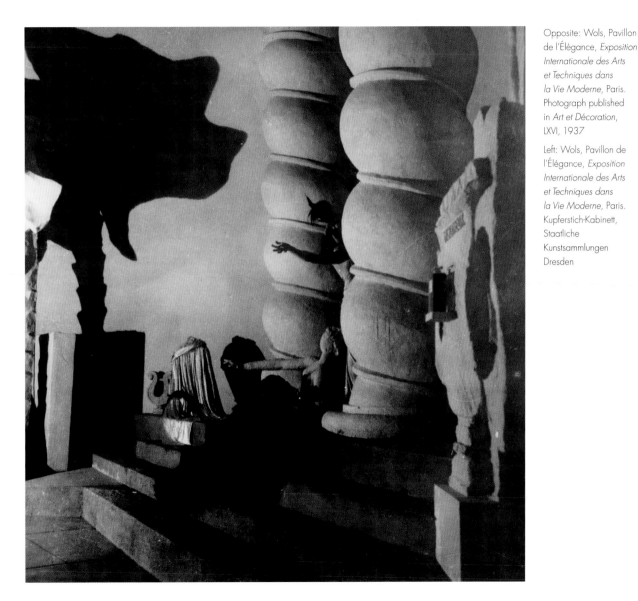

Opposite: Wols, Pavillon
de l'Élégance, *Exposition
Internationale des Arts
et Techniques dans
la Vie Moderne*, Paris.
Photograph published
in *Art et Décoration*,
LXVI, 1937

Left: Wols, Pavillon de
l'Élégance, *Exposition
Internationale des Arts
et Techniques dans
la Vie Moderne*, Paris.
Kupferstich-Kabinett,
Staatliche
Kunstsammlungen
Dresden

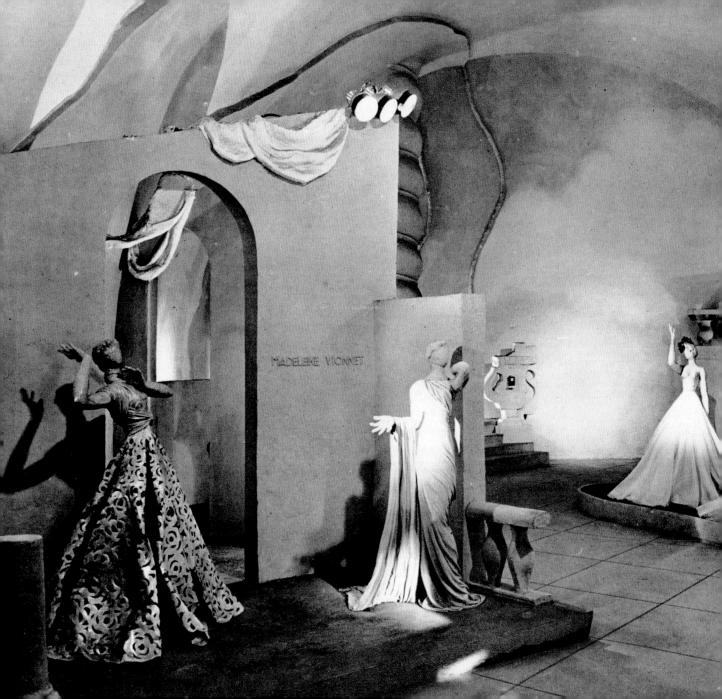

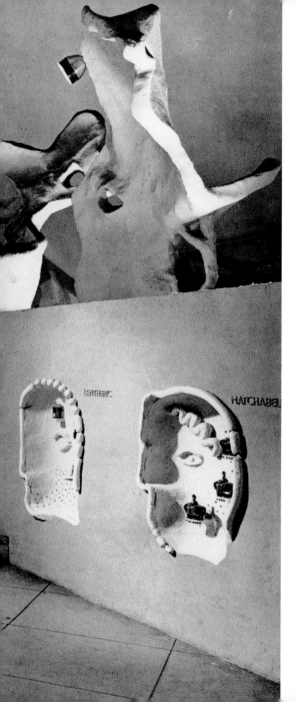

over two metres high and made of plaster, again broke the mould of traditional forms and materials. As a sculptor's preparatory material, Couturier was drawn to the medium, writing in *Les Lettres Françaises* that 'This material, so criticized and despised for its unpleasant aspect, almost worthless, lends itself very well to the expression of the sculptor who can obtain a remarkable plastic effect … Less by a deliberate asceticism, than by the exercise of the transfiguring powers of imagination.'[10]

The nascent quality of plaster might also have contributed to the development of the mannequin aesthetic. They were roughly modelled, elongated forms with giant hands posed in dramatic moments of declamation. The evocation of a gesture frozen in time, the momentary made eternal, as if the figure had been fossilized, was clear in Couturier's initial conception:

> I imagined a long, winding tunnel with the atmosphere of an ochre-toned Mediterranean town. Scattered here and there, in complete harmony with the décor, fantastic giants of terra cotta – but in fact a mixture of plaster and oakum – more than six feet tall, presented the public with a

Opposite: Wols, Pavillon de l'Élégance, *Exposition Internationale des Arts et Techniques dans la Vie Moderne*, Paris. Photograph published in *Art et Décoration*, LXVI, 1937

Next page left: Wols, Mannequins by Robert Couturier for Lanvin, Pavillon de l'Élégance, 1937. Photograph published in *Harper's Bazaar*, 15 September 1937

Next page right: Wols, Mannequin by Robert Couturier for Schiaparelli, Pavillon de l'Élégance, 1937. Schiaparelli France, Paris

Pavillon de l'Élégance

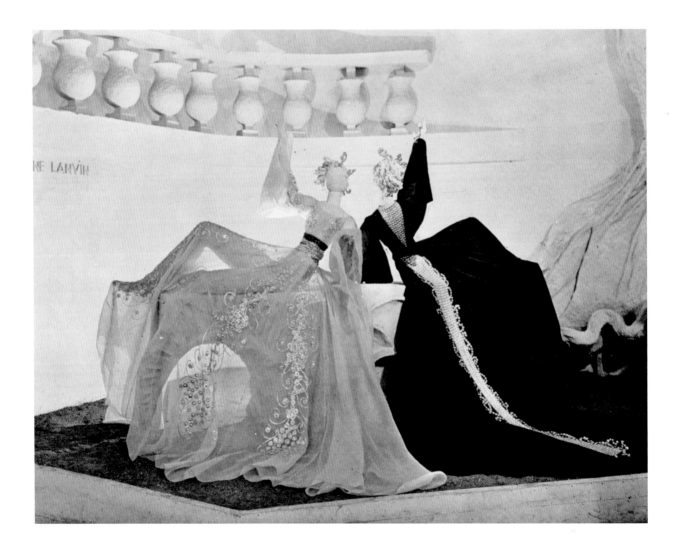

new silhouette: slim waists and powerful muscles. I wanted tragic silhouettes that were intentionally devoid of any of the pleasantness, the gentleness, that usually go with elegance. Their defensive frightened gestures, their featureless faces, their badly balanced bodies, recalling the inhabitants of Pompei surprised by a cloud of ashes rather than the habitués of the Faubourg saint-Honoré or avenue Montaigne. I didn't expect such violent reactions. There was an enormous scandal and a public demonstration.[11]

These mythic, fossilized figures were dressed in the most elegant French fashions by the leading couture houses. Jeanne Lanvin's delicately embellished evening gowns on their rough reclining figures with featureless faces created a particularly surreal tableau, as did Schiaparelli's mannequin which lay on a flowered lawn below a tree, entirely nude. Alix's Grecian-inspired dress of delicate pleats imbued her mannequin, posed against a column, with the aura of an ancient, and invested the plaster with a whole range of archaic references.

The mannequins and interiors were officially photographed by the German

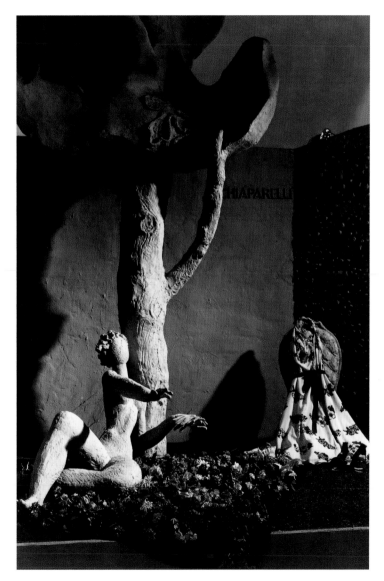

Pavillon de l'Élégance

Right: Wols, Mannequin
by Robert Couturier
for Alix, Pavillon de
l'Élégance, 1937, detail.
Kupferstich-Kabinett,
Staatliche
Kunstsammlungen
Dresden

Opposite: Wols,
Hands, Pavillon de
l'Élégance, 1937.
Kupferstich-Kabinett,
Staatliche
Kunstsammlungen
Dresden

photographer Wols (Alfred Otto Wolfgang Schulze), who documented the construction and installation. Rather than taking objective, documentary photographs, Wols explored the surreal aspects of the disembodied mannequins. Many of the photographs were taken at night and used strong lighting to create deep shadow. One particularly surreal shot showed the outstretched hands of the mannequin reaching up from a packing case as if buried alive. The slippage between real and false was made more eerie by the life-like shadows cast by the hands.

Wols' photographs were published in fashion magazines such as *Harper's Bazaar*, *Femina* and *Vogue*, and his images did much to promote the strange elegance of Couturier's mannequins. As Marcel Zahar described, the mannequins in turn did much to promote the fashions: 'Dresses that collapse and die as soon as they leave their flesh support and which do not regain their life on mannequins of wax – take here, on these delirious sculptures, in an atmosphere of pseudo-antique excavation, saturated by literature – a magic and new sense.'[12] The Surrealists were undoubtedly influenced by the mise-en-scène of the 1937 exhibition.

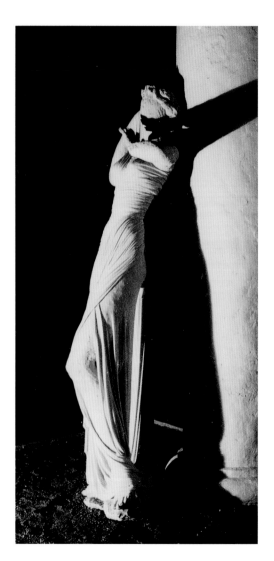

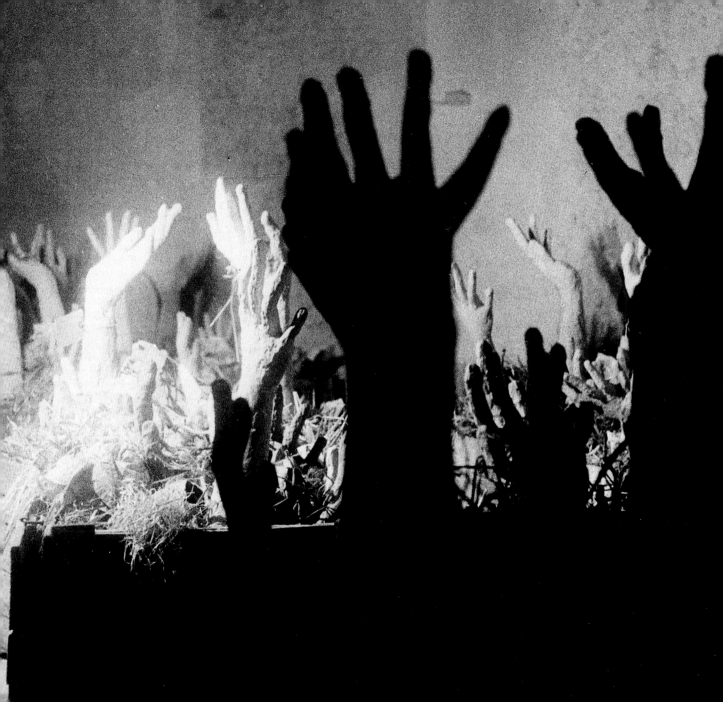

Mannequin Street

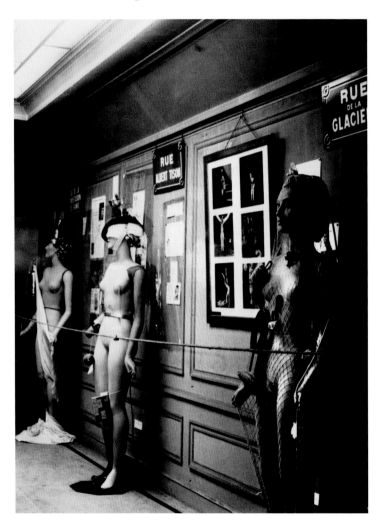

The *Exposition Internationale du Surréalisme* of 1938, held at the Galerie Beaux-Arts in Paris, represented the apogee of the Surrealist engagement with the mannequin. The Rue Surréaliste consisted of a corridor lined with sixteen shop window mannequins, each dressed by a different artist. Widely commented on at the time, it became the most infamous section of the exhibition, with its allusion to a red light district and its fetishistically dressed women. Georges Hugnet described the almost sexual excitement with which the artists dressed their mannequins: 'One could see the happy owners of mannequins ... come in, furnished with mysterious little or big bundles, tokens for their beloved, containing the most unlikely presents.'[13] Man Ray went further still, suggesting the process was akin to rape:

> In 1938 nineteen nude young women were kidnapped from the windows of the Grands Magasins and subjected to the frenzy of the Surrealists who immediately deemed it their duty to violate them, each in his own original

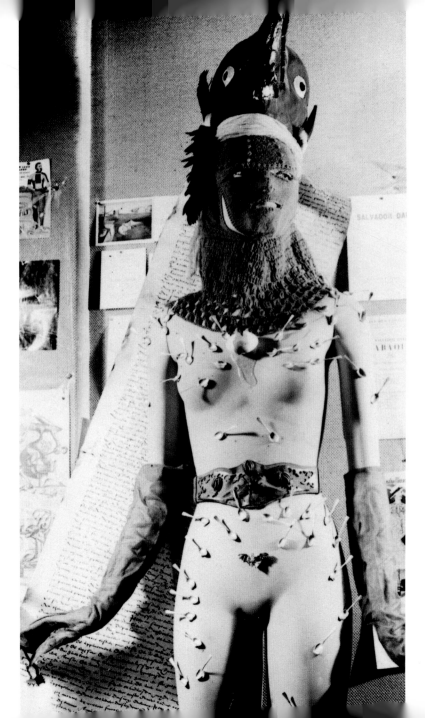

Opposite: Joseph
Breitenbach, Rue
Surréaliste, *Exposition
Internationale du
Surréalisme*, Galerie
Beaux-Arts, Paris.
Gelatin silver print.
1938. Collection Getty
Research Institute,
Los Angeles

Left: Mannequin
dressed by Salvador
Dalí, *Exposition
Internationale du
Surréalisme*, Galerie
Beaux-Arts, Paris.
Photograph. 1938.
Collection Getty
Research Institute,
Los Angeles

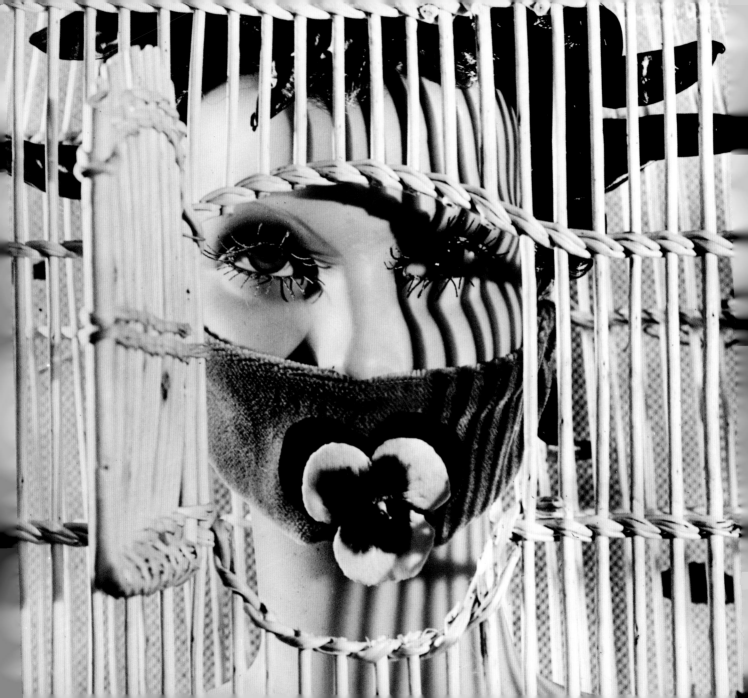

and inimitable manner but without any consideration whatsoever for the feelings of the victims who nevertheless submitted with charming good will to the homage and outrage that were inflicted on them, with the result that they aroused the excitement of a certain Man Ray who undid and took out his equipment and recorded the orgy.[14]

As Alyce Mahon has observed, each Surrealist transformed his mannequin into 'an animate object of desire through erotic or bizarre dress, accessories, posture and lighting'.[15] Duchamp's mannequin was the only one cross-dressed as a man and referred to Duchamp's female alter ego Rrose Selavy (*Eros, c'est la vie* – Eros, that's life), the subject of a series of photographs taken by Man Ray. In a reversal of his role as a woman, Duchamp had written Rrose across the pubis of the female mannequin dressed as a man.

André Masson's mannequin was widely regarded as the most successful. He placed a wicker cage over the head and gagged her with velvet, placing a pansy over her mouth. Ubac's powerful photographic close-up of her head became the defining image of the

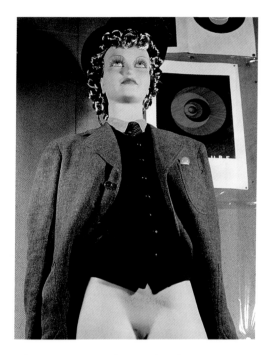

Opposite: Raoul Ubac, Mannequin dressed by André Masson, *Exposition Internationale du Surréalisme*, Galerie Beaux-Arts, Paris. Gelatin silver print. 1937. Collection Maeght, Paris

Left: Raoul Ubac, Mannequin dressed by Marcel Duchamp, *Exposition Internationale du Surréalisme*, Galerie Beaux-Arts, Paris. Gelatin silver print. 1938. Musée d'art moderne de la ville de Paris

submissive, erotic object – the ultimate subject of the male gaze.

Different sexual roles were posited by other mannequins, and several explored themes of violence and dismemberment, revealing the darker side of the eroticization of the mannequin.

The 1938 exhibition marked the high point and the end of the Surrealist fascination with the mannequin. Almost overloaded with meaning, the Surrealists moved on to find other vessels to impregnate with symbolism.

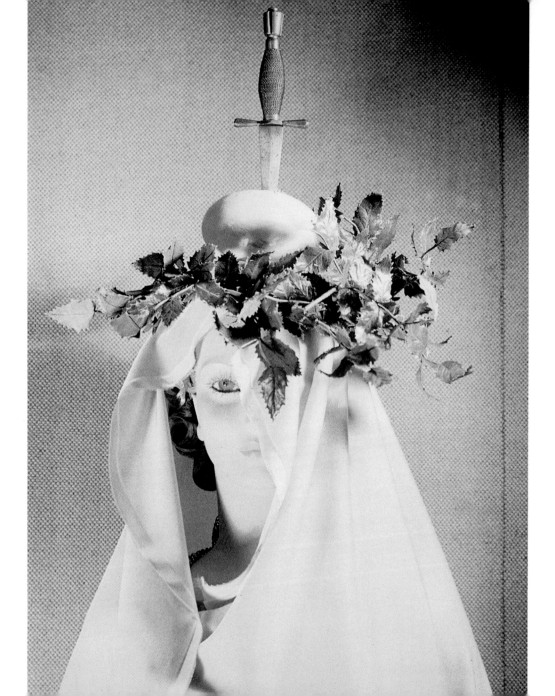

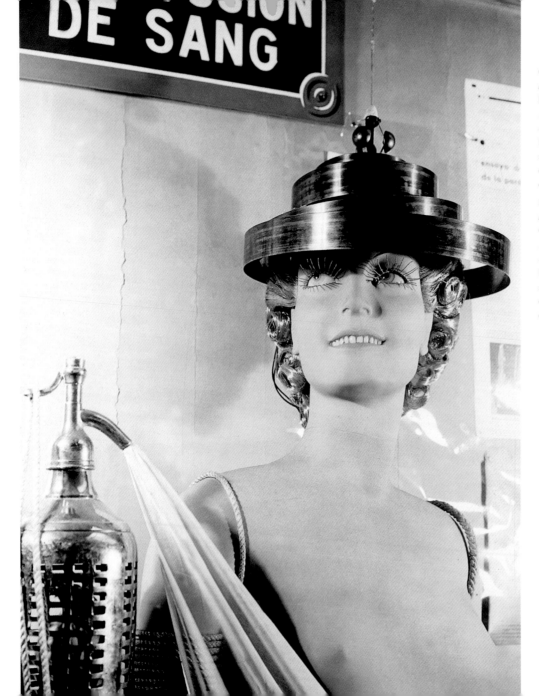

Opposite: Raoul Ubac,
Mannequin dressed
by Kurt Seligmann,
*Exposition Internationale
du Surréalisme*, Galerie
Beaux-Arts, Paris. Gelatin
silver print. 1938. Musée
d'art moderne de la ville
de Paris

Left: Raoul Ubac,
Mannequin dressed by
Oscar Dominguez,
*Exposition Internationale
du Surréalisme*, Galerie
Beaux-Arts, Paris. Gelatin
silver print. 1938. Musée
d'art moderne de la ville
de Paris

The Fetish

Fetishization was one of the most prevalent strategies at work in Surrealism. The focus of sexual desire on a part of the body or object was explored in innumerable texts, photographs, paintings, films and objects. Freud's description of the creation of the fetish provided a language of motifs:

> ... it is as though the last impression before the uncanny and traumatic one is retained as a fetish. Thus the foot or shoe owes its preference as a fetish ... to the circumstances that the inquisitive boy peered at the woman's genitals from below, from her legs up; fur and velvet ... are a fixation of the sight of pubic hair, which should have been followed by the longed for sight of the female member; pieces of underclothing, which are so often chosen as a fetish, crystallize the moment of undressing, the last moment in which the woman could still be regarded as phallic.[16]

An imagery of body parts – eyes, breasts, hands, legs and feet – became the fare of Surrealism during the 1930s, and was quickly subsumed into commercial advertising

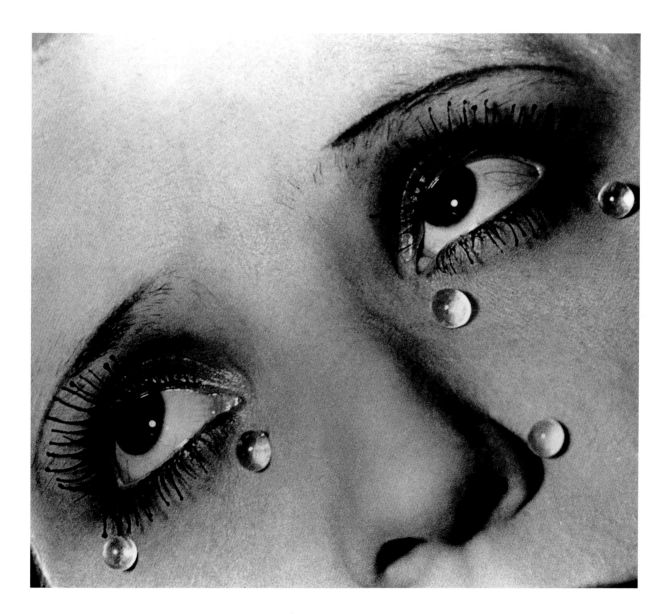

The Fetish

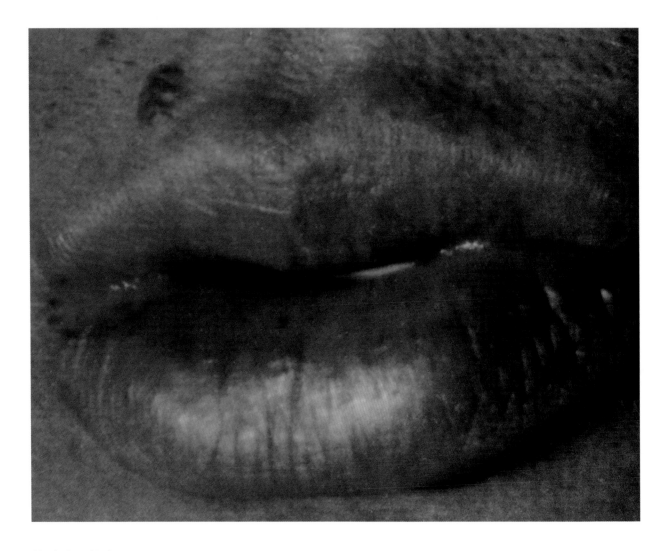

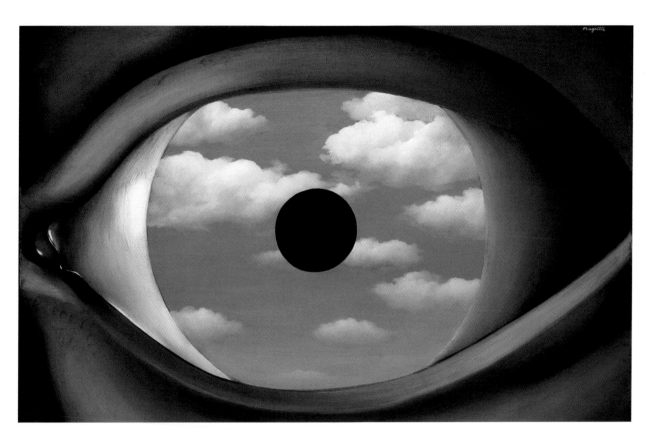

Previous page left: Leo Dohmen, *L'Ambitieuse* (The Ambitious). Vintage gelatin silver print. 1958. Galerie Ronny Van de Velde, Antwerp, Belgium

Previous page right: Man Ray, *Larmes* (Tears). Gelatin silver print. *c.*1930. Private Collection

Opposite: Roger Parry, Untitled. Photograph. 1931. The Metropolitan Museum of Art, New York

Above: René Magritte, *The False Mirror*. Oil on canvas. 1928. The Museum of Modern Art, New York

The Fetish

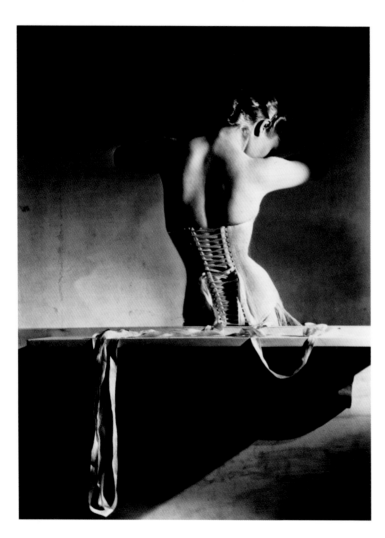

as a powerful signifier of desire; a desire that could be fulfilled through consumption.

Lips first appeared in the second Surrealist Manifesto of 1929, while a photograph by Roger Parry of 1931 disturbingly drew a parallel between oral and vaginal imagery. Carefully framed, this mouth had none of the glossy artifice of Dalí's lips. Eyes, with their long symbolic and poetic lineage, could be apertures onto the unconscious or the dream world, as in Magritte's *The False Mirror* (1928). Alternatively, they were malign mechanisms of the gaze to be desecrated, as in Dalí and Buñuel's film *Un Chien Andalou* (An Andalucian Dog), where an eye is sliced open with a razor.

Marcel Jean's comments on the 1938 Surrealist exhibition might easily stand for Surrealism more generally: 'And everywhere there were hands; the hand as a symbol of Surrealism industrious and dreaming, hands floating on the fluorescent liquids contained in compartments of a table constructed by Hugnet, Fire-Fly hands escaping from the sides of a vase (Seligmann), hands that were door-knobs and the hand outstretched over

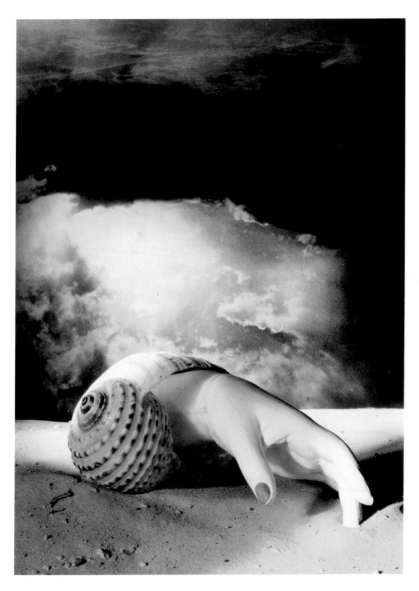

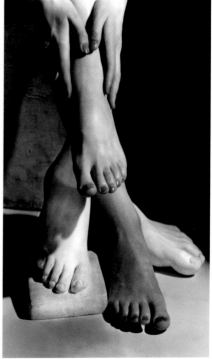

Opposite: Horst [Horst Paul Albert Bohrmann], *Girl with Mainbocher corset*. Gelatin silver print. 1939. V&A: Ph.222–1985

Left: Dora Maar, Untitled. Gelatin silver print glued on cardboard. 1933–4. Musée d'art moderne de la ville de Paris

Below: Horst [Horst Paul Albert Bohrmann], *Barefoot Beauty*. Gelatin silver print. 1941. Galerie Volker Diehl, Berlin

The Fetish

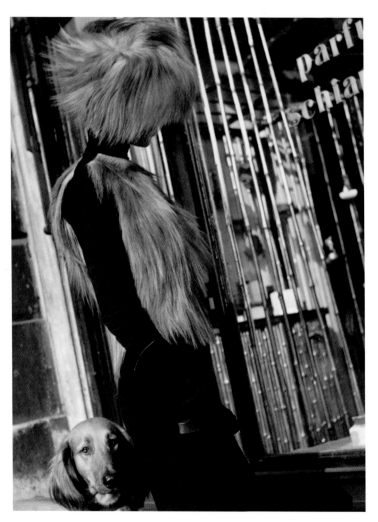

the silent, revolving record of Dominguez' gramophone, Never.'[17] Man Ray consistently returned to the imagery of the hand in both his commercial and art production.

Fur or velvet provided a particular focus for the fetish, with its obvious association with pubic hair. Moreover, the Surrealist veneration for Leopold von Sacher-Masoch's novel *Venus in Furs* of 1870 provided a masochistic import to the conflation of body and fur. Dalí's *Venus with Drawers* (1936) cheekily reinterpreted Masoch's awe at a magnificent marble Venus draped in a sable coat. In Dalí's *Venus* humorous tufts of fur act as draw pulls.

The fetishistic imagery of fur also allowed for an exploration of the concept of man as animal, inherent in the primitive desires of the Freudian id. This theme provided a thread through La Comte de Lautreamont's (the pseudonym of Isidore Ducasse) *Les Chants de Maldoror* (The Songs of Maldoror), a seminal text for the Surrealists. It was perhaps most clearly revealed, however, in the myth of the Minotaur – where man and animal fused. An irrepressible force of nature, the Minotaur was another favourite theme of Surrealism.

Opposite: Model in front
of the Schiaparelli shop.
Schiaparelli France, Paris

Left: Salvador Dalí,
Venus with Drawers.
Bronze and fur. 1936;
reconstruction of 1964.
Museum Boijmans Van
Beuningen, Rotterdam

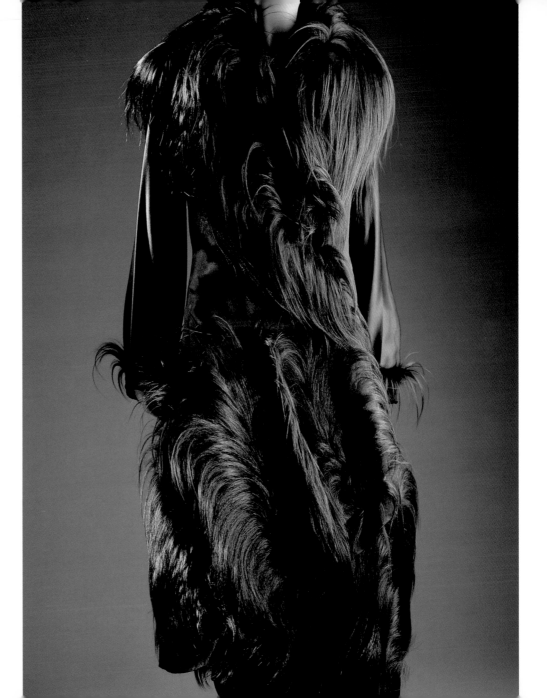

The Fetish

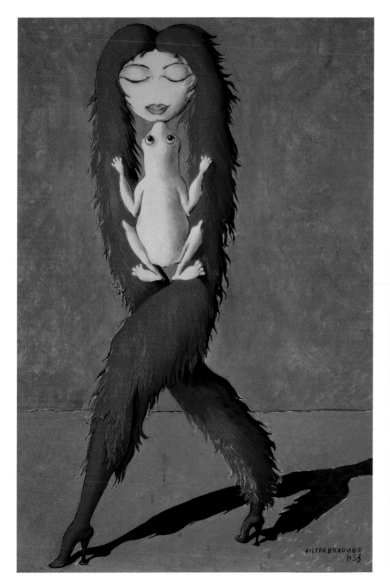

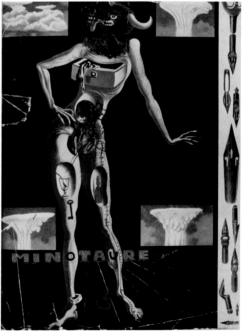

Opposite: Elsa
Schiaparelli, Coat.
Monkey fur, lined with
black silk satin. 1938.
Los Angeles County
Museum of Art

Left: Victor Brauner,
L'Objet qui reve II
(Object Which Dreams
II). Oil on canvas.
1938. Museum of
Contemporary Art,
Chicago

Below: Salvador Dalí,
Figure with drawer.
Cover design for
Minotaure, no.8, 1936.
NAL SD.95.0019 (Vol.II)

Bodies Transformed: Surrealist Women

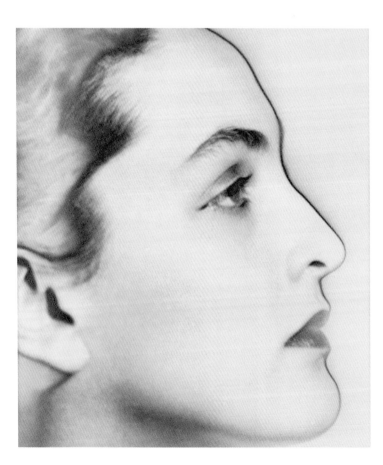

Whether muse, mother, *femme-enfant*, erotic object or Ur goddess, women were a primary subject of Surrealism. For many male artists, women became the vessel through which to explore a variety of psychological and emotive states. Women were seen as being closer to nature, and by extension the unconscious.[18] In his novels *Nadja* (1928) and *L'Amour Fou* (1937), André Breton employed love/desire, mediated by women, to explore the Surrealist experience of the 'marvellous'. Alongside Breton's more romantic vision, many artists explored a darker seam, objectifying, dismembering and fetishizing the female body.

The response of women artists associated with Surrealism to this imagery of objectification within a discourse established largely by male artists produced complex and arresting works. As Madeleine Cottenet-Hage has observed, they engaged in the 'redesigning of traditional body representations', creating 'an unstable body, made of parts that can be disassembled and recombined in fanciful ways'.[19] The body

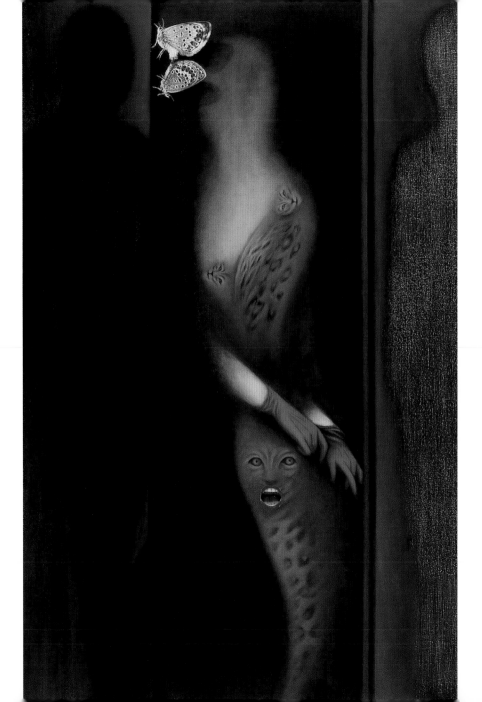

Opposite: Man Ray, Portrait of Meret Oppenheim. Gelatin silver print. 1933. V&A: Ph.68–1984

Left: Toyen [Marie Cermínová], Screen. Oil on collage on canvas. 1966. Musée d'art moderne de la ville de Paris

Bodies Transformed: Surrealist Women

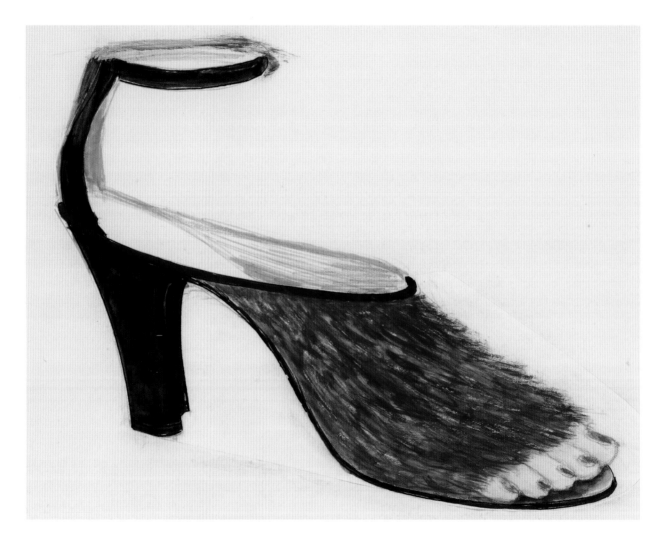

no longer exemplified canonical beauty, in part or whole, but in the hands of these women artists was transformed or transmuted to another state in both imagery and form. They literally made objects of their bodies and manipulated traditional visions of the female form. For many women artists, the boundaries of the self were not limited by the image, but spread to the object, home and the body. Several developed a corporeal imagery rooted in deeply subjective fantasies; the ghostly apparition of a woman who from below the waist is an animal with an erotically positioned human mouth, is disturbingly trapped between two men on the Czech artist Toyen's screen of 1966.

The genesis of Meret Oppenheim's most famous object, the fur-covered teacup, saucer and spoon, reinforces the allusion to corporeality at the heart of this iconic work. In spring 1936 Oppenheim produced designs for jewellery for Elsa Schiaparelli, one of which was a fur-lined metal bracelet. She was wearing this bracelet when she met Dora Maar and Picasso at the Café Flore in Paris. Picasso remarked that anything could be covered in fur, and Oppenheim responded by suggesting a cup and saucer. 'Objet', as it was first titled, was created for the first *Exposition Surréaliste d'Objets*, held at the gallery of Charles Ratton in Paris in May

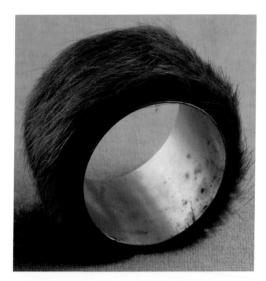

Opposite: Meret Oppenheim, Project for sandals. Pencil and watercolour. 1936. Private Collection, Sweden

Left: Meret Oppenheim, bracelet. Fur (beaver), metal. 1935. Collection Clo Fleiss, Paris

Below: Meret Oppenheim, Fur-covered cup, saucer and spoon. 1936. The Museum of Modern Art, New York

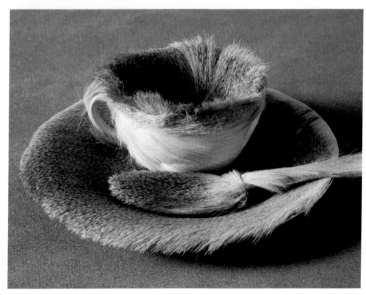

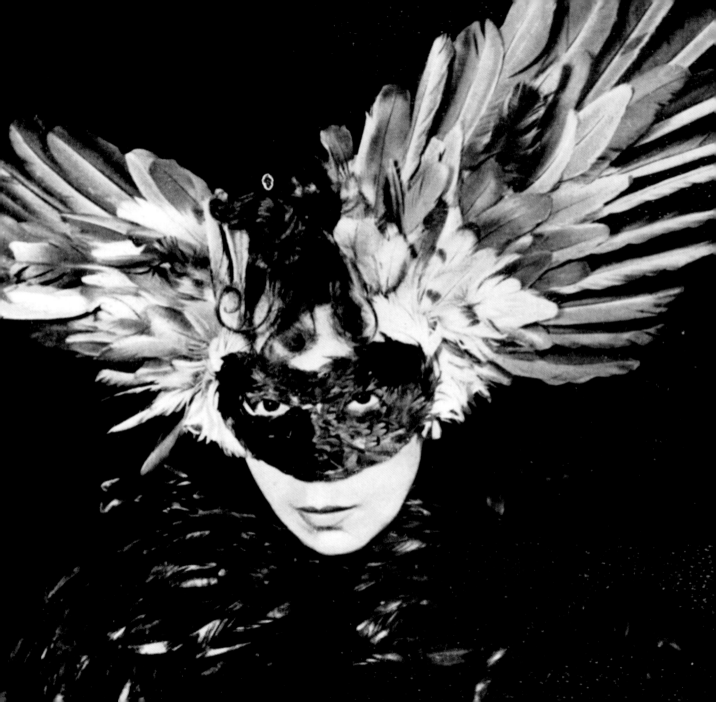

1936, where it immediately became an archetype of the surreal object and established Oppenheim's reputation.

The idea of a second skin explicit in the design for the bracelet is inherent in the fur teacup, which was retitled *Le déjeuner en fourrure* (Breakfast in Fur) by Breton. The title combined the scandalous female sexuality represented in Edouard Manet's *Déjeuner sur l'Herbe* (1863) and the sexual fetishism implied by the play on the title of Sacher Masoch's *Venus in Furs* (1870). The eroticism conveyed by the concave fur-covered form of the teacup into which was placed the phallic spoon was heightened by the imagined sensation of oral contact with the furry cup. The cup is a cipher for the female sex. Oppenheim later described it as the 'image of femininity imprinted in the minds of men and projected on to women'.[20]

The fur teacup and saucer was followed by a group of fur-lined objects, including a pair of gloves (1936) and a drawing for fur shoes, which in combining the imagery of foot, shoe and fur explored the complexities of the fetishized female body.

Meret Oppenheim and Leonor Fini were close friends whose correspondence reveals their shared interests and motivations. Many letters discuss ideas for objects and fashion,

some of which were realized and others only imagined. An undated letter from Oppenheim to Fini of the late 1930s discusses the design for a new fashion: 'Please find attached sketches of objects I made today, including the "écharpes-perruques" (wig-scarves)'; while another describes works designed but not sold: 'These sketches are not too bad, and I still have old things that never got sold, the buttons with a footprint, the toothed wheel clips, etc., drawings for gloves and mittens and flasks.'[21] The correspondence reveals that for both women what they wore, how they looked and

Opposite: Leonor Fini wearing a feathered mask. Photograph published in *Vogue*, *Album d'Hiver*, 1946. NAL: PP.1.A

Below: Leonor Fini, *Armoire anthropomorphe* (Anthropomorphic Wardrobe), detail. Oil on canvas on wood. 1939. Collection of Rowland Weinstein, courtesy of Weinstein Gallery

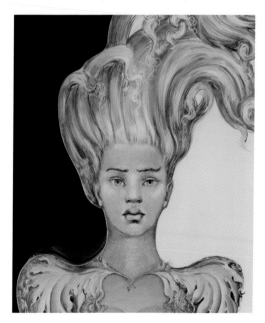

Bodies Transformed:
Surrealist Women

Right: Leonor Fini,
Armoire anthropomorphe.
Oil on canvas on wood.
1939. Collection of
Rowland Weinstein,
courtesy of Weinstein
Gallery

Opposite: Leonor Fini,
La Peinture (Painting)
and *L'Architecture*
(Architecture). Oil
on canvas, mounted
on wood. 1939.
Collection of Rowland
Weinstein, courtesy
of Weinstein Gallery

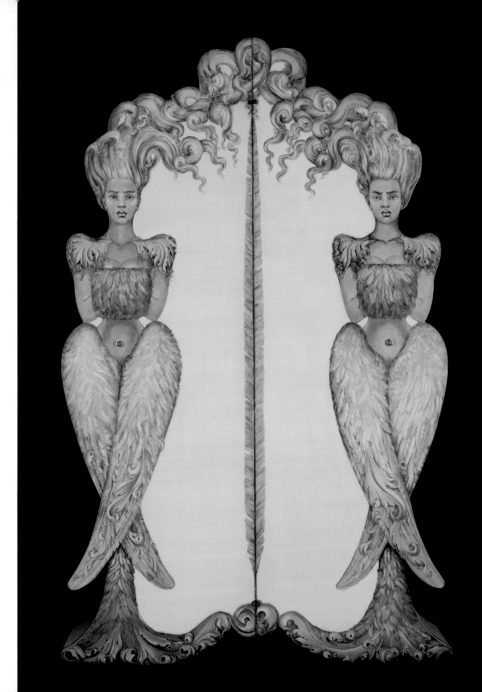

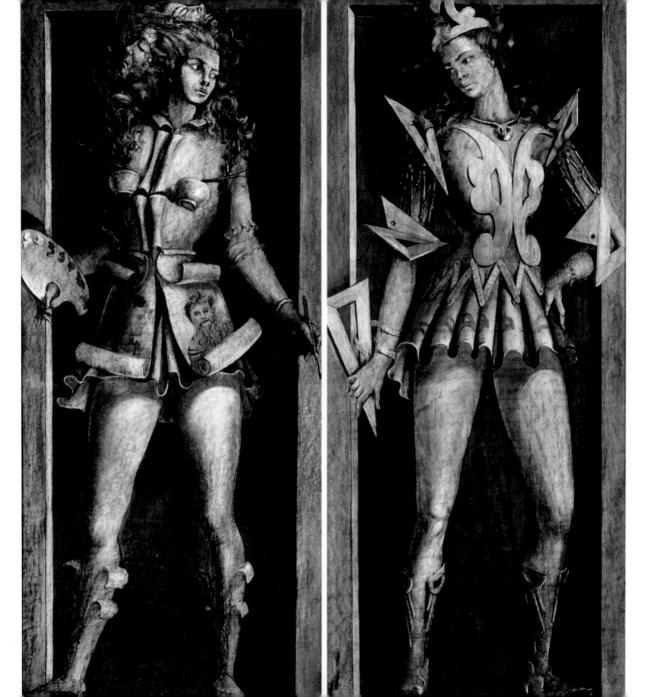

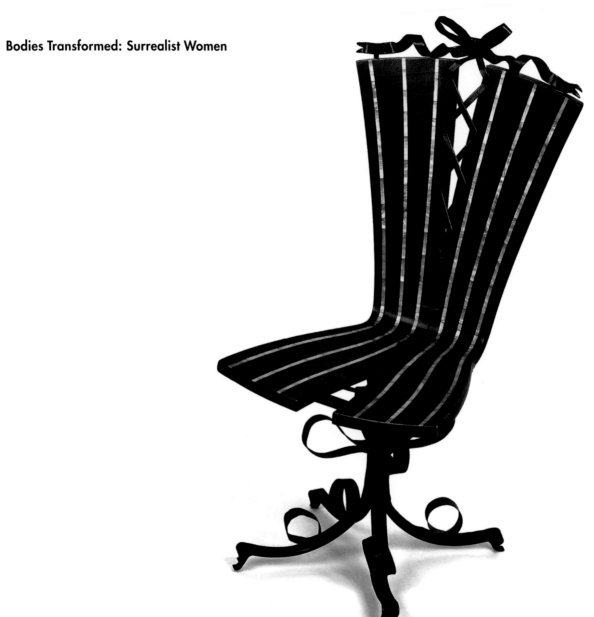

what they made were integrated spheres in their artistic lives.

For Leonor Fini this was particularly true. Fini was born in Buenos Aires in 1907 but came to live in Trieste before moving to Paris when she was eighteen. Her non-conformity, flamboyant dress and eccentric personality made her an immediate sensation. Her sense of showmanship appealed to the Surrealists: 'she arranged a rendezous in a local café and arrived dressed in a cardinal's scarlet robes: "I like the sacrilegious nature of dressing as a priest, and the experience of being a woman and wearing the clothes of a man who would never know a woman's body"'.[22]

The theme of the body transformed is particularly prevalent in her oeuvre. Often figured as half animal, half human, Fini's powerful and alluring women frequently assume her features. Her extraordinary *Armoire Anthropomorphe*, made for the Drouin exhibition in Paris in 1939, is at once sensual and disturbing. The swan-winged women are simultaneously figures from a metamorphic myth and fashionable modern women. The cabinet shape itself is formed by the imprint of these majestic creatures and assumes a corporeal presence.

Two panels representing Architecture and Painting, also made for the Drouin exhibition, represent Fini in a different guise. Here, she is an heroic medieval knight, a Joan of Arc, defending the arts. The crafted historicism of these panels, which are executed in grisaille (the figures don historical costumes and attributes), relates to the conscious adoption by many of the women Surrealists of what Whitney Chadwick has referred to as the hermetic tradition.[23] They rejected positivism and explored medieval and occult practices – pursuing a cult of the feminine. Fini refused to formally join the Surrealist group, feeling that Breton's preoccupation with formal positions was bourgeois and constricting.

The British Surrealist Eileen Agar's relationship with Surrealism was, like Fini's, ambivalent: 'One day I was an artist exploring highly personal combinations of form and content, and the next I was calmly informed I was a Surrealist!'[24]

Agar's first objects stem from her affair with Paul Nash in Swanage in 1935. The two artists collected objects they found together on the beach and began developing a shared iconography of the *objet trouvé* (found object). Agar later incorporated these objects into a variety of works. The *Ceremonial Hat for Eating Bouillabaisse*, which literally crowned woman with the mantle of nature, bringing one into a direct relationship with the other, was

Opposite: Leonor Fini, Corset chair. Stained wood, mother of pearl and wrought iron. 1939. Private Collection

Bodies Transformed: Surrealist Women

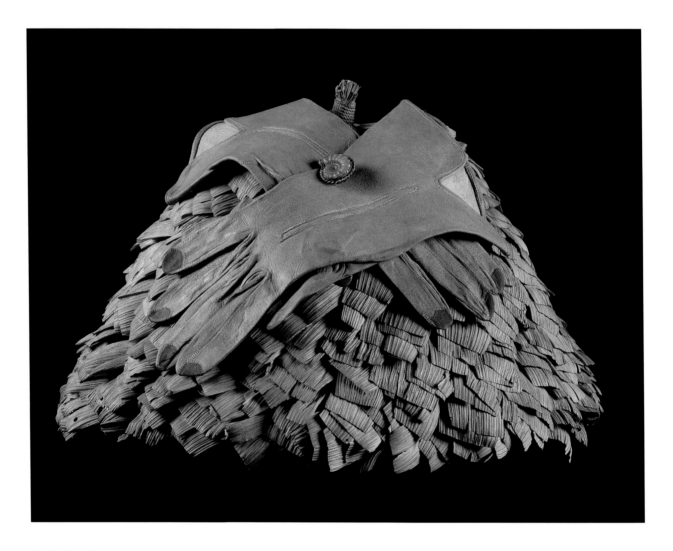

made during a visit to the south of France in 1936. She later wrote: 'It consisted of a cork basket picked up in St Tropez and painted blue, which I covered with fishnet, a lobster's tail, starfish and other marine objects. It was a sort of Arcimboldo headgear for the fashion-conscious, and received a lot of rather startled publicity.'[25] This hat was one of the most complex works made with found seashore objects, and in its titling and theatricality clearly owed a debt to Dalí.

Her *Glove Hat* privileged the surreal trope of displacement by positioning a pair of Schiaparelli's gloves with pink fingernails on the head. The gloves, which Agar had previously worn, were pinned with an ammonite, perhaps a found object of the summer of 1935, and thus the hat suggests the sense of an autobiographical act. The *Glove Hat* was probably made in the same year as the *Bouillabaisse*, and both may have mined an autobiographical vein, having been inspired by her mother's 'spectacular headgear'.

The American Surrealist Dorothea Tanning is perhaps best known for her meticulously executed paintings of mysterious interiors, but in a small group of works of the late 1960s she explored the body in three dimensions. The *Rainy Day Canapé* (1970) and the *Nue Couchée* (or Reclining Nude) (1969–70)

are soft sculpture/objects and both explore the erotic melding of objects and bodies. The rounded organic forms are given limbs and vertebrae but fuse with other inanimate forms. The title *Nue Couchée* wittily evokes but subverts traditional notions and compositions of the nude – its pink, soft texture suggesting skin. *Rainy Day Canapé*, executed in a traditional upholstery fabric, envisions a nude and sofa involved in an erotic encounter.

These women artists manipulated the imagery of their own bodies and clearly positioned themselves in relation to the Surrealist discourse by creating objects which referenced the body. Regeneration was perhaps the key theme they explored through the transformation of the body.

Opposite : Eileen Agar, Hat with Schiaparelli gloves. Palm leaf, kid leather. 1936. V&A: T.169–1993

Below: Eileen Agar, *Ceremonial Hat for Eating Bouillabaisse*. Wood, plastic and shells. 1936. V&A: T.168–1993

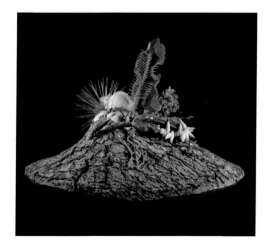

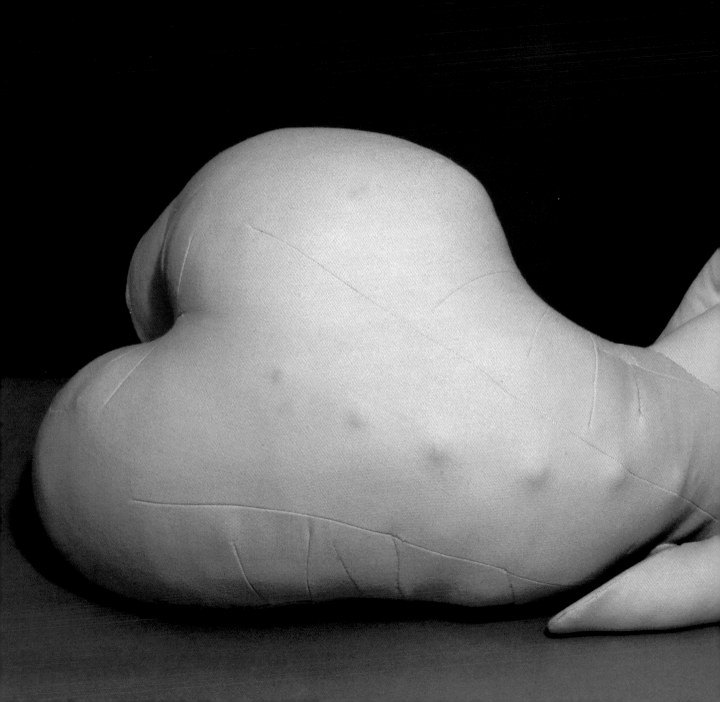

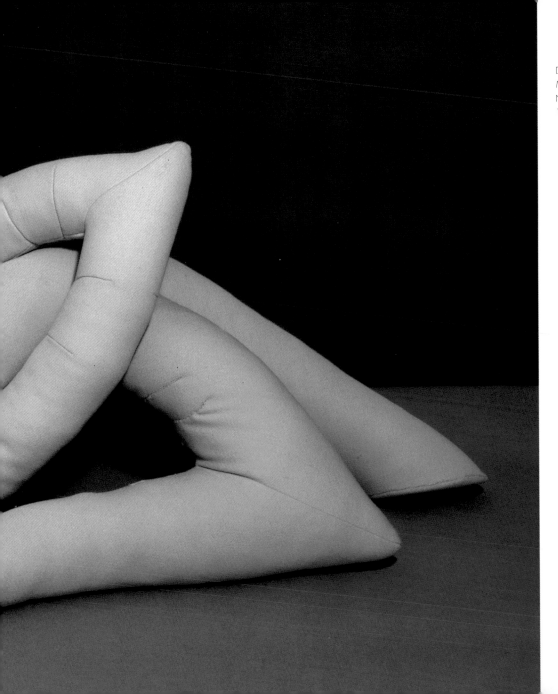

The Shop Window

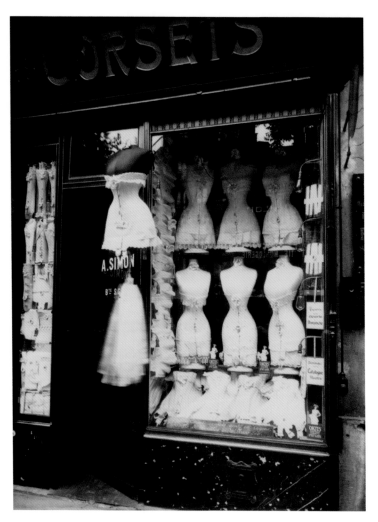

For the Surrealists, it was not just the mannequin that was seen as incipiently surreal, but also the shop window. The embodiment of consumer culture, the shop window became, in a typically Surrealist dichotomy, the ideal proscenium for desire, both self-reflexive and representative of consumerism.

Eugène Atget's documentary photographs of the shop fronts and metalwork of late nineteenth-century Paris particularly appealed to the Surrealists. His mostly unpopulated images represented fragments of a bygone, or soon to be lost city. The vision they presented of contemporary life, reflected in the plate glass windows and superimposed onto often outmoded commodities, provided the Surrealists with a metaphor for modern life and the alienation created by Capitalist consumer culture, a theme that Louis Aragon explored in *Le Paysan de Paris* of 1926.

The Surrealists often returned to the shop window in text, image and practice. For example, in 1945 Marcel Duchamp and Enrico Donati created Surrealist shop window displays for the publication of André Breton's books *Surrealism and Painting* and *Arcane 17* in New York. Donati later recalled that the window for *Arcane 17* was only on display at Brentano's store for a couple of

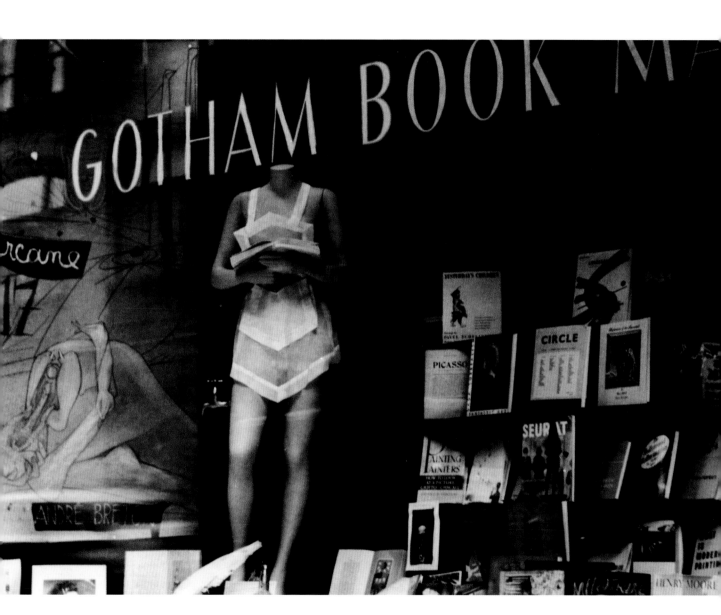

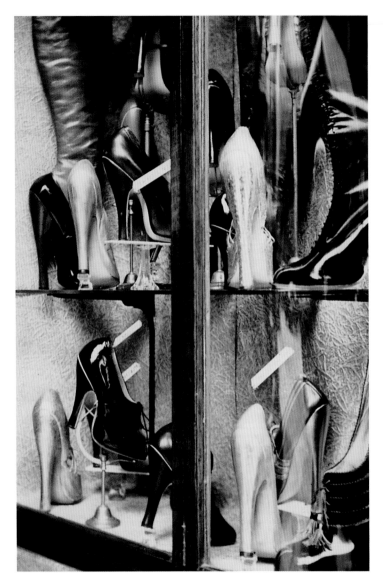

hours before people came in to complain. Duchamp had dressed a headless mannequin in an apron holding Breton's book; from a faucet attached to the upper thigh urine flowed. The display was moved to Gotham Book Mart.

The shop window was one of the first commercial areas to be transformed by Surrealism, its visual tricks appropriated 'in order to cash in on the secret languages of objects, subjects and their mutual desires explored by the movement'.[26] Its political and revolutionary intentions were of course entirely ignored. This process of assimilation was inexorably fuelled by Dalí's notorious activities in the field. His first window, entitled 'She was a surrealist woman, She was like a figure in a Dream', was created for Bonwit Teller's Fifth Avenue store in 1936 and coincided with the Fantastic Dada and Surrealism exhibition at the Museum of Modern Art. A mannequin with a head of roses was posed in the centre of the window, while arms draped with jewellery reached towards her like branches of a tree.

It was, however, his Bonwit Teller windows of 1939 which became infamous and resulted in the headline 'Bathtub Bests Surrealist Dalí in 5th Ave. Show Window Bout'.[27] Entitled 'Night' and 'Day', the windows featured a

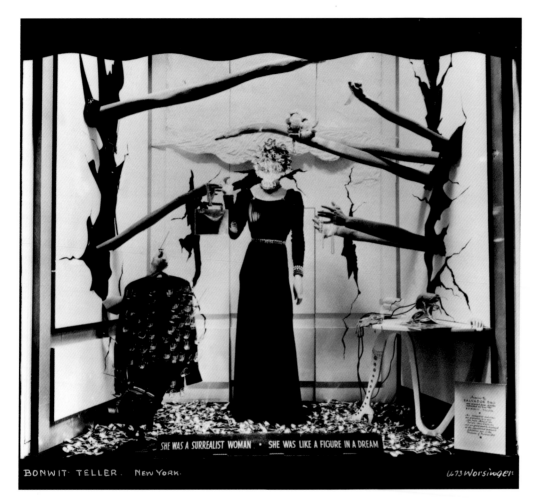

SHE WAS A SURREALIST WOMAN • SHE WAS LIKE A FIGURE IN A DREAM

BONWIT·TELLER· NEW YORK.

Previous page left:
Eugène Atget, *Boulevard de Strasbourg (Corsets)*.
Gelatin silver print.
1912. The Museum of Modern Art, New York

Previous page right:
Enrico Donati and Marcel Duchamp, Shop window, Gotham Book Mart.
1945. Philadelphia Museum of Art

Opposite: Claude Cahun, Shop window with shoes. Gelatin silver print. *c.*1936. Musée national d'art moderne de la ville de Paris

Left: Salvador Dalí, Bonwit Teller shop window on Fifth Avenue, New York. 1936. Museum of the City of New York

Next page left: Pascale in the perfume boutique, Schiaparelli shop, Place Vendôme, Paris. Schiaparelli France, Paris

Next page right: Display of 'Sleeping' perfume, Schiaparelli shop, Paris. 1947. Schiaparelli France, Paris

wax mannequin representing Night on a bed with a mattress of glowing coals, and another representing Day dressed in a red wig and green negligée leaning over a bath lined with astrakan. In response to protests from the public, the management of the store changed the mannequins overnight, and Dalí, furious, tipped the bath through the window. Whether

The Shop Window

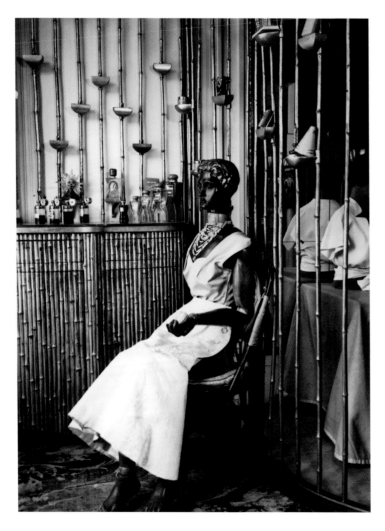

intentional or not, it made Dalí's popular reputation in America.

Elsa Schiaparelli was one of the first designers to consistently use a Surrealist 'style' for her shop windows. Her assistant, Bettina Bergery, whom Dalí described as 'the soul and biology of the Schiaparelli establishment … one of the women of Paris most highly endowed with fantasy. She exactly resembled a praying mantis, and she knew it',[28] created surreal tableaux in the window of the Place Vendôme shop. One featured a polar bear (which had been given to Dalí by Edward James), dyed pink, and into which Dalí had cut drawers; jewellery spilled from the cavities. After 1937, Schiaparelli's window featured the extraordinary cage designed by Jean Michel Frank for her perfume business, which was incorporated in early 1938. The delicate cage made of gilded bamboo with a black frame painted with green and red flowers created a surreal space in which often sat Pascale or Pascaline, the shop's resident mannequin couple. Schiaparelli, perhaps more than any other designer, understood the commercial pulling power of the Surrealist trope.

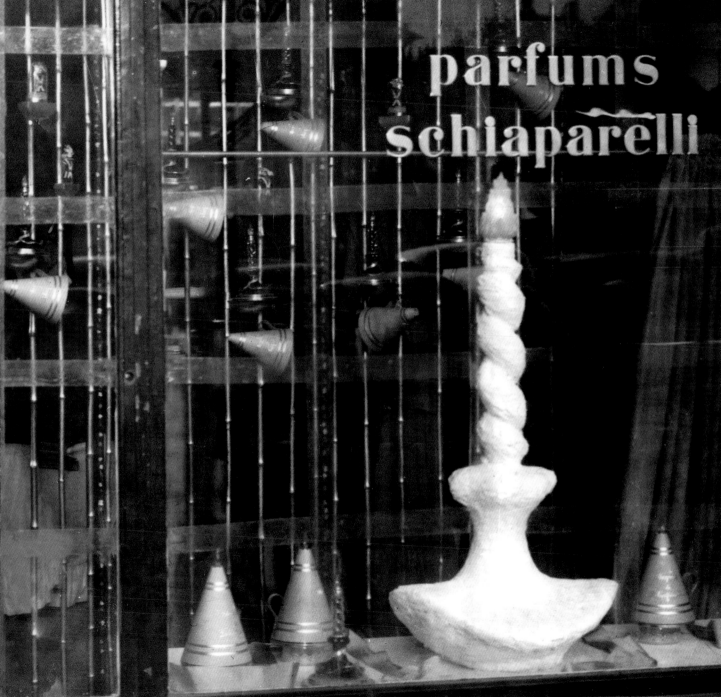

Surreal Fashion

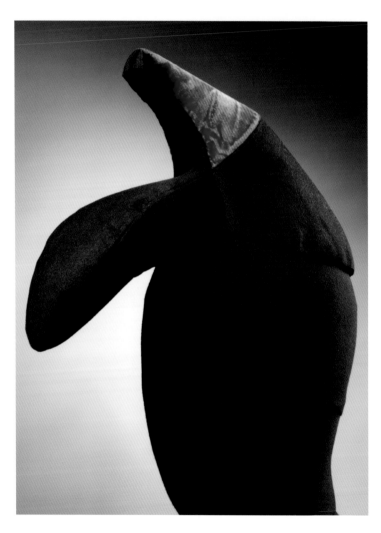

The application of psychology to clothing was a growing field in the 1930s and aided the assimilation of Surrealist ideas by the fashion industry. J.C. Flügel's famous book *The Psychology of Clothes* (1930), following Freud, outlined the symbolic value of clothing:

> It is only in the last few years that there has been any clear realization of the fact that clothes not only serve to arouse sexual interest but may themselves actually symbolize the sexual organs. Here again psycho-analysis has added considerably to our knowledge, and has shown that in the domain of clothes phallic symbolism is scarcely less important than, for instance, in the domain of religion ... we know, however, that a great many articles of dress, such as the shoe, the tie, the hat, the collar and even large and more voluminous garments such as the coat, the trousers, and the mantle may be phallic symbols, while the shoe, the girdle and the garter (as well as most jewels) may be corresponding female symbols.[29]

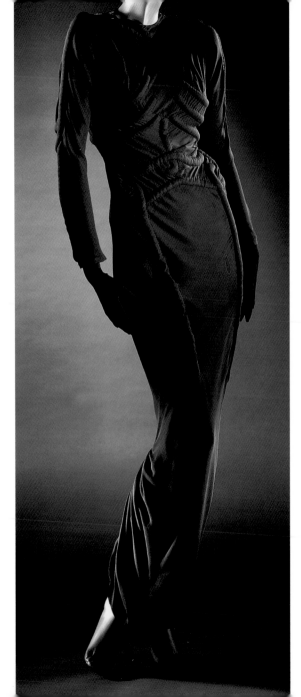

Opposite: Elsa
Schiaparelli, 'Shoe'
hat (collaboration with
Salvador Dalí). Black
wool felt. 1937.
Private Collection

Left: Elsa Schiaparelli,
'Skeleton' evening dress.
Black crêpe. 1938. V&A:
T.394–1974

Below: Salvador Dalí,
Design drawing for
'Skeleton' dress. Indian
ink on paper. 1938.
Schiaparelli France, Paris

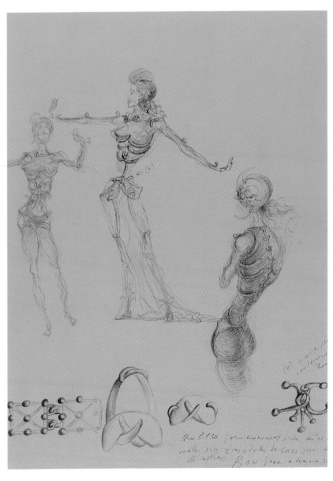

Surreal Fashion

Following Flügel, Tristan Tzara developed an explicit fetishization of fashion in his article 'On a Certain Automatism of Taste', published in *Minotaure* in 1933. Illustrated with photographs by Man Ray of Schiaparelli's hats, it explored their sexual symbolism, but in a reversal of Freud's phallic reading, Tzara saw them as representative of female genitalia. From the early 1930s, Schiaparelli was then very well versed in the sexual and psychological implications of clothing and readily exploited these in her collections.

Her most overtly surreal works were the result of her collaboration with Dalí. From late 1936 they developed a series of ideas that would radically alter the way in which fashion and Surrealism were perceived. Dalí later wrote of the opening of the Schiaparelli shop in the Place Vendôme, 'Here new morphological phenomena occurred; here the essence of things was to become transubstantiated; here the tongues of fire of the Holy Ghost of Dalí were going to descend.'[30] Through Schiaparelli and Dalí's work, the body was refashioned by Surrealism and Surrealism subsumed into the cultural mainstream.

Most of Dalí's ideas were realized in the collections of 1937–38. The most famous

example of Surrealist displacement, the shoe hat with its pink velvet high heel, appeared in the winter collection, and in the summer of 1938 came two of the most powerful collaborative works: the 'Skeleton' and 'Tear' dresses. These extraordinary pieces brilliantly combined morbidity and humour and represented the height of their collaboration.

Dalí's fascination with the theme of corporeality, often realized through the use of bone-shaped soft structures, informed the development of the Skeleton dress. The imagery of bones can be seen in many works from the mid 1930s, and is particularly prevalent in his etchings for *Les Chants de Maldoror* of 1934. Schiaparelli's realization of this corporeal imagery in 'skin tight' black silk jersey provided the illusion of a second skin, with the 'faux anatomy' sitting proud on the fine matt silk surface.[31] The bones were created using the technique of trapunto quilting, which produced a subtle and sensual effect. Almost more alien than human, the Skeleton dress is one of the most surreal works of 1930s. It was worn with a long black veil and miniature gold snail shell.

Continuing the corporeal theme, the Tear dress presented an imagery of torn and desecrated flesh. The puce blue ground, now sadly faded in the surviving examples, must

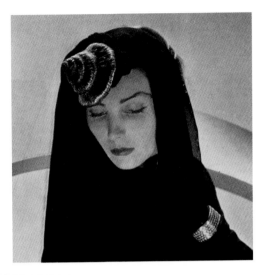

Opposite: Elsa Schiaparelli, 'Skeleton' evening dress, detail. Black crêpe. 1938. V&A: T.394–1974

Left: Elsa Schiaparelli, Veil with gold snail shell. Photograph published in *Vogue*, March 16, 1938

have added to the sense of morbidity. The motif of the torn dress/flesh appeared first in Dalí's painting of 1936, *Three Young Surrealist Women Holding in Their Arms the Skins of an Orchestra*, in which the surface of a rose-headed woman is ripped and torn. Schiaparelli's interpretation of the painting combined the illusory and the real. The fabric of the dress was printed with a trompe l'œil pattern of torn flesh, while for the mantle the tears were actually appliquéd. The pale stripes of fabric peeled back to reveal a livid pink beneath.

Dalí was not the only Surrealist artist to work with Schiaparelli. The French artist, poet and film-maker Jean Cocteau produced two

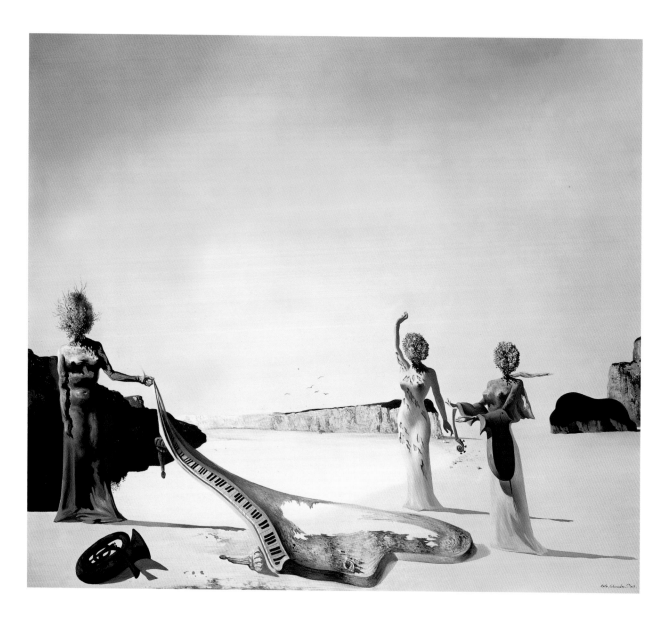

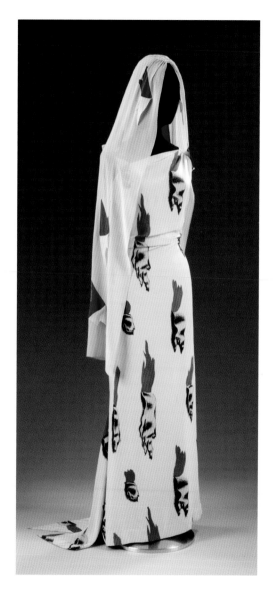

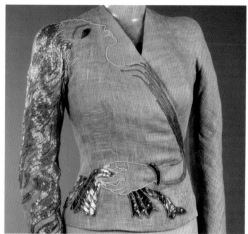

Opposite: Salvador Dalí, *Three Young Surrealist Women Holding in Their Arms the Skins of an Orchestra*. Oil on canvas. 1939. Salvador Dalí Museum, St Petersburg, Florida

Far left: Elsa Schiaparelli, 'Tear' evening dress. Fabric designed by Salvador Dalí. Silk crêpe. 1938. V&A: T.393–1974

Left: Elsa Schiaparelli, Evening jacket (collaboration with Jean Cocteau). Embroidered grey linen, gilt metal thread, bugle beads and paillettes. Autumn 1937. Philadelphia Museum of Art

drawings which were translated into a design for an evening coat and a jacket for the autumn 1937 collection. In September that year Cocteau had also illustrated one of Schiaparelli's dresses for American *Harper's Bazaar*. The design for an evening coat reveals Cocteau's preoccupation with the double image, an idea to which he consistently returned. The strong linear design can be read as two profiles facing each other, or as a vase of roses standing on a fluted column.[32] The use of bold lines to define the composition is typical of Cocteau's style and was elegantly translated into embroidery by the Paris firm of Lesage.[33] The grey linen evening jacket is a tour de force of bugle beading. A woman's profile appears on one

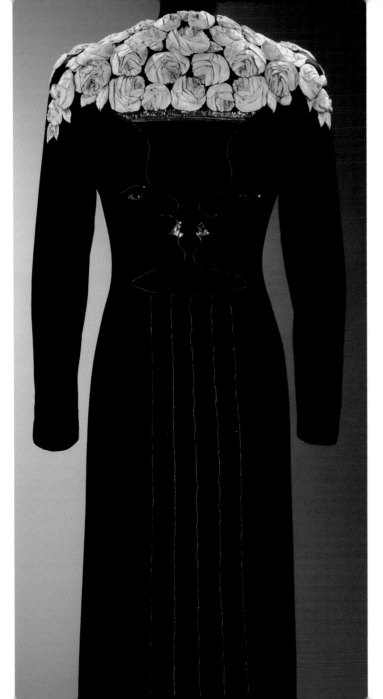

side of the jacket, while her blonde hair literally flows down the sleeve.

Beyond her direct collaborations with artists, which included designs for jewellery from Meret Oppenheim, Louis Aragon, Elsa Triolet and Alberto Giacometti, and for perfume bottles from Giacometti, Dalí and Leonor Fini, Schiaparelli incorporated Surrealist themes into her own designs. A gilded copper braid coat and stole of 1938 literally transformed fabric into gold, giving form to a Surrealist alchemic fantasy (see p.9). The fascination with medieval occult practice, and particularly alchemy, exemplified in the work of Leonora Carrington for instance, seems to inform the design of this extraordinary coat, the weight of which must have provided the sensation of being literally encased in gold.

Metamorphosis was the theme of Schiaparelli's collection of 1937, which included a pale pink dress covered with multicoloured butterflies, while a long evening dress, similarly decorated, was worn with a mesh coat evoking the idea of a butterfly net. The fascination of artists such as Max Ernst and Man Ray with the butterfly as a symbol of metamorphosis and transformation was humorously exploited in Schiaparelli's design in which a woman-butterfly is captured.

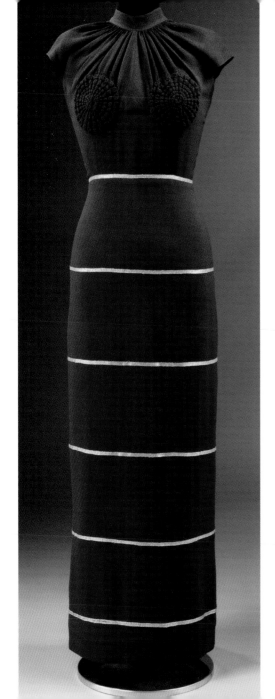

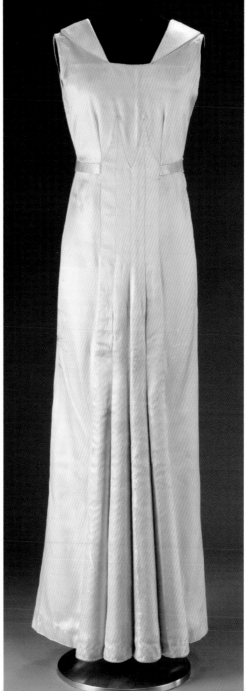

Opposite: Elsa Schiaparelli, Full-length evening coat with design by Jean Cocteau, embroidery by the firm of Lesage, and appliqué silk decoration. Dark blue silk jersey. Autumn 1937. V&A: T.59–2005

Far left: Elsa Schiaparelli, 'Etruscan' dress. Brown crêpe and gold braid. 1935–36. V&A: T.36–1964

Left: Elsa Schiaparelli, 'Column' dress. Cream satin. 1938. V&A: T.335–1987

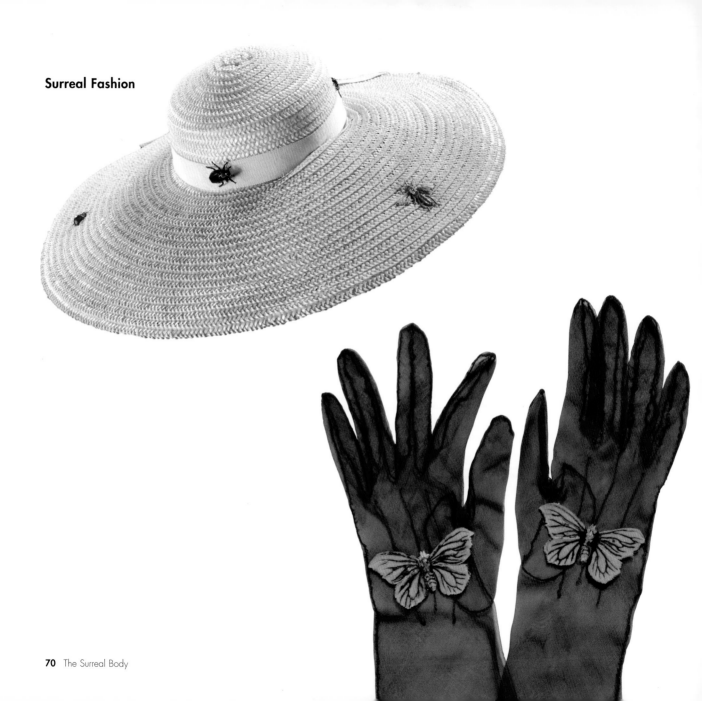

Surreal Fashion

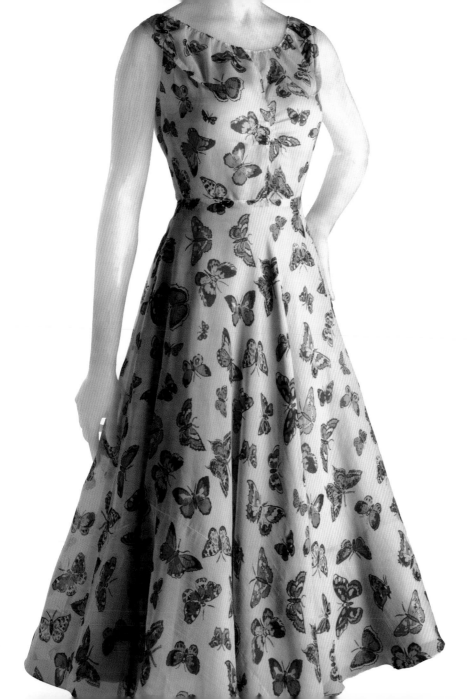

Opposite top: Elsa
Schiaparelli, Hat with
insects. Straw. 1950s.
V&A: T.427–1974

Opposite bottom: Elsa
Schiaparelli (attr.),
Evening gloves. Silk and
velvet. *c.* spring/summer
1938. Mark Walsh
Leslie Chin

Left: Elsa Schiaparelli,
Waltz-length evening
dress. Ivory organdie
with multicoloured
butterfly print. Summer
1937. Philadelphia
Museum of Art

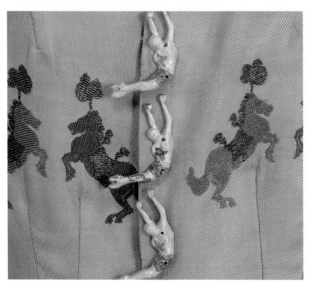
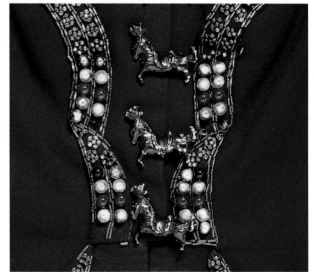

Butterflies and insects were favourite motifs for her accessories and made startling buttons.

Many of her most surreal touches were in the elaborate decoration of jackets and coats. A jacket of 1938 was decorated with brightly coloured pieces of mirror and beading that create the bizarre forms of four lamb chops, while another of the same year had embroidered pockets shaped as pink lips, undoubtedly referencing Dalí's *Mae West Lips* sofas which were to furnish Schiaparelli's London shop. The millionaire patron of the Surrealists, Edward James (for whom the lips sofas were made), remembered that it was to be '"Shocking Pink" – made popular by the dressmaker Schiaparelli. Dalí was very specific in insisting on the sofa being this shade … Dalí wanted it the glossiest satin possible, so as to resemble lipstick … Schiaparelli was so delighted when she saw the shocking pink mouth, that she ordered me to make two like it.'[34] Edward James recalled that Schiaparelli did not collect the sofas, but she incorporated the lips motif into a jacket, worn with the shoe hat.

Accessories which included hats, shoes, bags, gloves, necklaces and hair clips also provided an opportunity for creating humorous surreal works. A pair of black gloves with red snakeskin fingernails of 1936 reversed a famous Man Ray photograph of a pair of hands painted by Picasso to resemble gloves. From necklaces hung garden tools, vegetables or pine cones, and collars were covered with a profusion of roses or insects. From a pair of ankle boots, made by André Peruglia, monkey fur flowed to the floor, recalling Magritte's painting *Love Disarmed* (1935), in which long blonde hair streams from a pair of shoes placed before a mirror.

If Schiaparelli's greatest skill lay in the application of Surrealist imagery and tropes to

Opposite: Elsa Schiaparelli, decorative elements from clothes and accessories. V&A

Below: Elsa Schiaparelli, Lamb chop jacket. Black wool marocain, mirrors. 1938. V&A: T.392–1974 ·

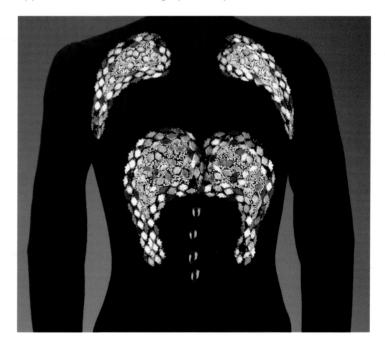

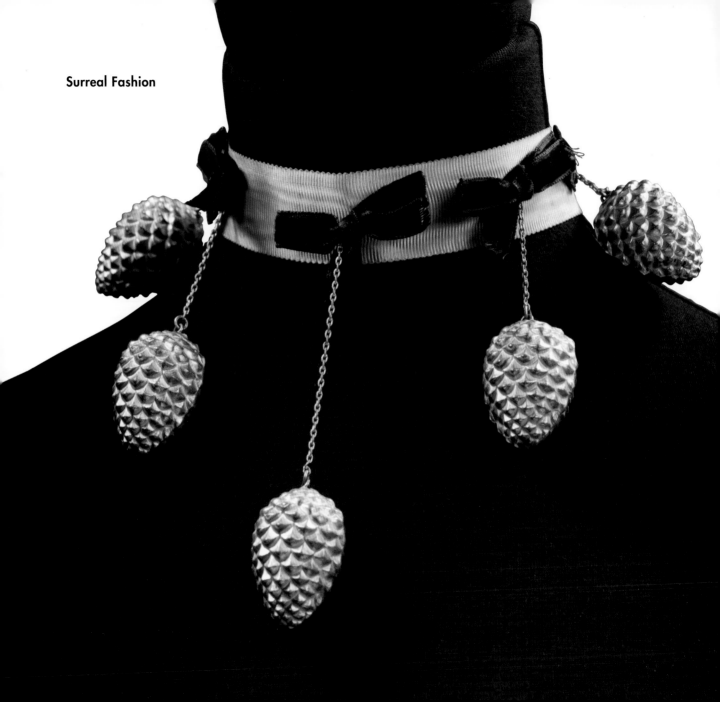

Surreal Fashion

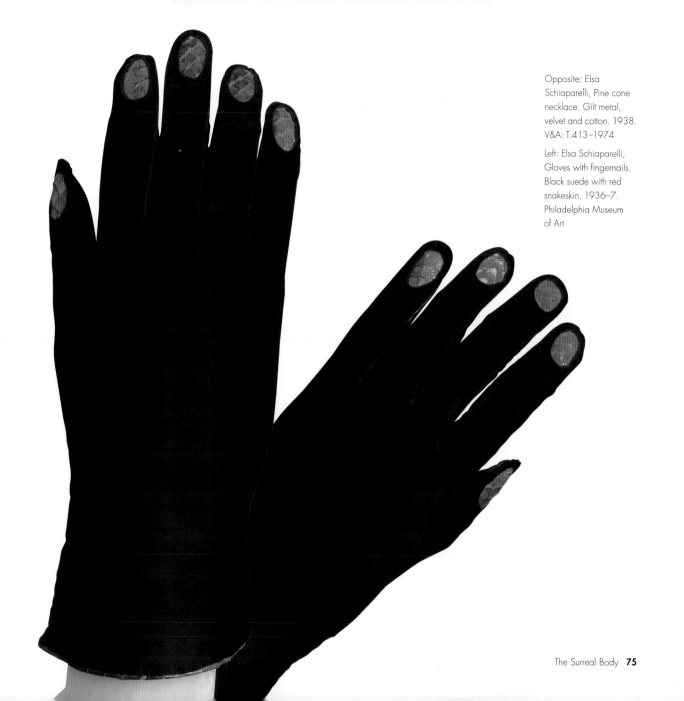

Opposite: Elsa
Schiaparelli, Pine cone
necklace. Gilt metal,
velvet and cotton. 1938.
V&A: T.413–1974

Left: Elsa Schiaparelli,
Gloves with fingernails.
Black suede with red
snakeskin. 1936–7.
Philadelphia Museum
of Art

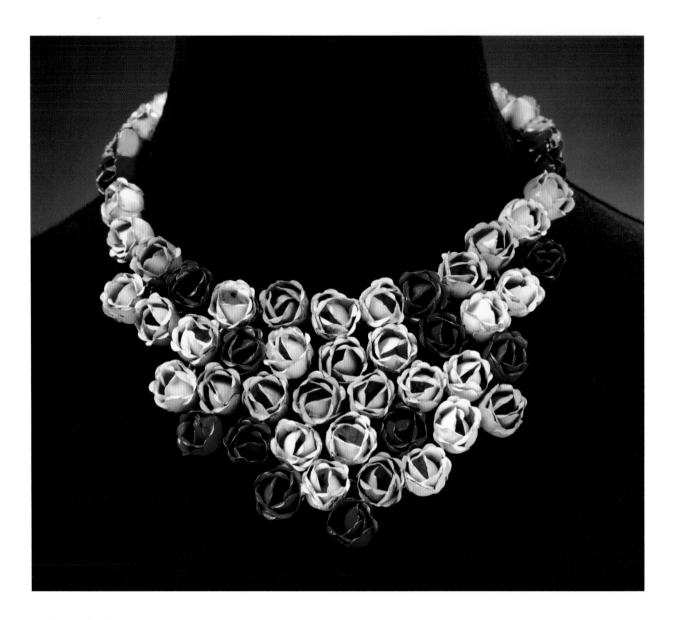

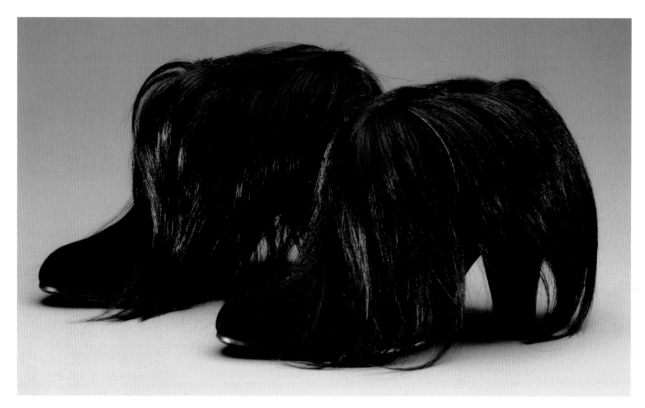

fashion, Charles James's was in the creation of surreal structures that refashioned the body. One of the most technically skilled designers of the time, the American James gained a reputation for creating dramatic eveningwear. His experimentation with form is apparent in an evening coat of 1936. Although from the front the coat appears to be quite conventional in structure, from the side an extraordinary profile is revealed. Stiff fins extend from the back and the arms creating an aggressive, dehumanized shape. The coat transfigures its wearer into automaton – part machine, part human – recalling the Surrealist fascination with automatons and their elision of the organic and inorganic, man and machine.

By contrast, his eiderdown-filled jacket of 1937 creates a compellingly gentle silhouette.

Opposite: Elsa Schiaparelli, Rose bib necklace. Enamelled metal. c.1938. Mark Walsh Leslie Chin

Above: Elsa Schiaparelli, Boots. Black suede and black monkey fur. Summer 1938. Philadelphia Museum of Art

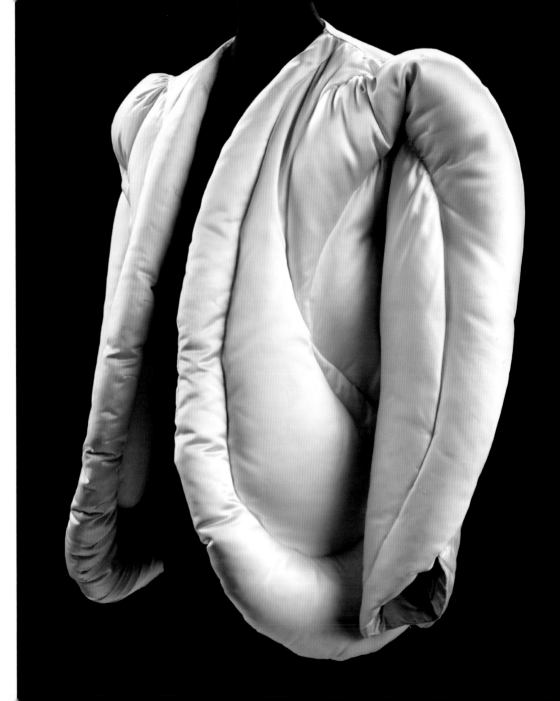

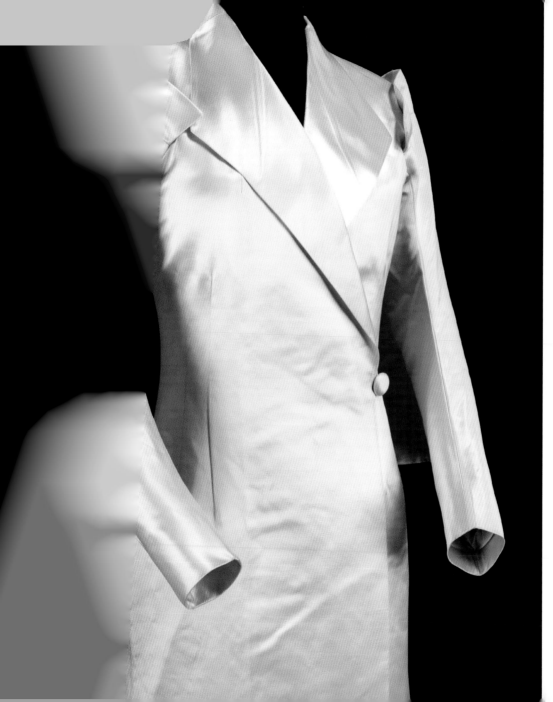

Opposite: Charles James, Evening jacket. White quilted satin. 1937. V&A: T.385–1977

Left: Charles James, Evening coat. Cream satin. 1936. Mark Walsh Leslie Chin

Surreal Fashion

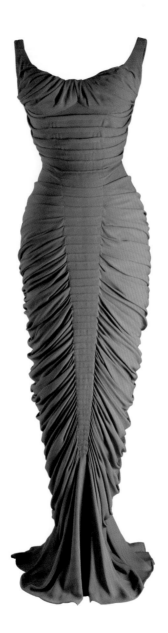

Made of deeply padded white satin, Dalí described it as the first soft structure.[35] The jacket employs a profoundly organic and sensual language that precipitates the psychological and physical need to touch. The 'Sirène' dress of 1938 also employs this language but accentuates the erotic. Again the psychological and the physical are brought together in the structure of the dress. The form is created by the gathering of the fabric into a ribbed panel at the centre front. The skin-like gathers create a sensual effect accentuated by the figure-hugging silhouette. The central panel also brings to mind the overlapping shell structure of a crustacean, adding a metamorphic symbolism to the dress.

Like the Sirène dress, Schiaparelli's black evening dress of 1945 also employs an organic and erotic language of figure-hugging

gathers. Down the front of the skirt runs a strange spine which ends in a flared anthropomorphic tail (recalling the alien or animal aspect of the Skeleton dress). Yet what in the Sirène dress is metaphoric is here made explicit. At the front over the pubic area is a metal zip – alluring in the accessibility it provides, but terrifying in its symbolism. The metal teeth of the zip allude to the vagina dentata. As Dalí observed in *Eroticism in Clothing*, 'Costumes are a constant metaphor of the erogenous zones, transformed by psychomotive means – attracted, suggested, exhibited, hidden, sublimated through history – the permanent presence of Eros, ensuring in this way the perpetuation of the human species toward the Angels.'[36] Their role, in his words, to 'Hide … Protect … Provoke!'

Opposite: Charles James, 'Sirène' evening dress. Silk crêpe. c.1955. The Museum at the Fashion Institute of Technology, New York

Left: Elsa Schiaparelli, 'Spine' dress. Black silk jersey. 1945. V&A: T.49–1965

Dalí's Jewels

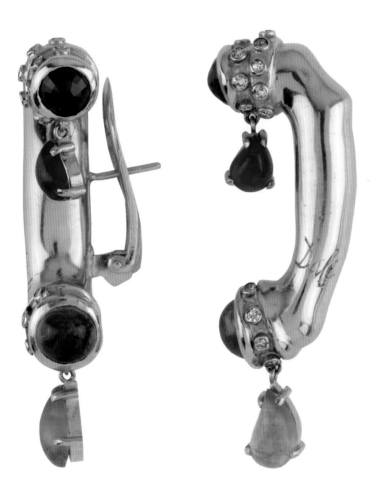

Although Dalí had worked with the jewellery designer Fulco di Verdura in the early 1940s, in 1949 he signed a contract to produce pieces with the Argentinian jeweller Carlos B. Alemany and the Finnish shipping magnate Eric Ertman.[37] It was to be an extremely productive relationship and resulted in some of Dalí's most famous jewels, which often adapted motifs derived from paintings.[38]

The melted watch which first appears in the *Persistence of Memory* (1931) was realized as a gold and diamond brooch, while Mae West's lips were brilliantly reconfigured as a dazzling ruby mouth with pearl teeth. Dalí wrote of this piece: 'poets of the ages, of all lands, write of ruby lips and teeth like pearls. It remained for Dalí to translate this poetic cliché into a true surrealistic object'.[39] Rubies were used to represent flesh, creating a tension between the sensuality of real flesh and the hard allure of the precious stones, while the displacement of the lips from the mouth to the body accentuated the idea of fetishization. Many of Dalí's designs for jewels explored the imagery of the body, and particularly the theme of fetishization.

A piece which pursues a complex corporeal relationship is the 'Étoile de Mer' (or 'Starfish') brooch created for Rebecca Harkness. This extraordinary work is a

Opposite: Salvador Dalí,
Telephone ear clips.
18-carat gold, diamonds,
natural rubies and
natural emeralds. 1949.
Private Collection

Left: Salvador Dalí, Ruby
Lips brooch. 18-carat
yellow gold, natural
rubies and pearls. 1949.
Primavera Gallery,
New York

Below: Salvador Dalí,
Leaf-veined case.
18-carat yellow gold,
natural emerald and
natural rubies. 1953.
Primavera Gallery,
New York

technical tour-de-force. Each arm is fully articulated and can be manipulated into any position, evoking the flexibility of the living creature. For Dalí the motif was part of a larger iconography of sea creatures associated with his home in Cadaques, which appear in both his writing and painting, but also relate to a wider interest in the starfish within Surrealism.[40] Man Ray, for instance, had made it the subject of his 1928 film *Étoile de Mer*.

The design drawing reveals that Dalí envisioned the starfish sensually entwined

Dali's Jewels

around the wearer's hand, highlighting the organicism of the subject. It also introduces the theme of the double – here the starfish becomes a substitute or double for the hand, the arms literally mimicking fingers. This association is made all the more intriguing by the way Rebecca Harkness wore the brooch clasping her breast. The intimate position leads to an obvious substitution of the starfish for the hand, and the creation of an erotic dialogue between object and subject accentuated in the technical sophistication of its physical 'grasp'. By positioning the piece in different correspondences to the body, a range of associations could be generated.

The 'Étoile de Mer' recalls the fascination with nature and the erotic ambiguity of Art Nouveau, but unlike the hermetic symbolism of the fin-de-siècle, the piece needs the participation of the viewer in order to create meaning. In this sense it is a true Surrealist object.

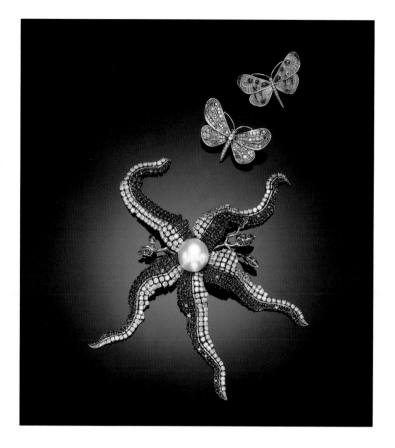

Opposite: Salvador Dalí, design for Starfish brooch. Watercolour on paper. 1950. Private Collection

Above: Salvador Dalí, Starfish brooch. Pearl, diamonds, rubies, emeralds and gold. 1950. Private Collection, Minneapolis, Minnesota, USA

The Dream of Venus

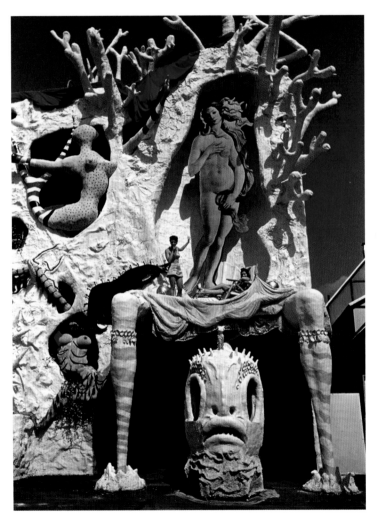

The Dream of Venus pavilion at the New York Worlds Fair of 1939 was the product of Dalí's surreal fantasies meeting the commercial realities of the entertainment industry head on. Loosely based on the theme of Venus, the pavilion was a surreal 'girly show', where semi-clad women swam, slept and posed under the voyeuristic eye of a mainly male paying audience. Situated in the amusement section of the exhibition at Coney Island, its commercial intentions were clear from the outset. Dalí, now notorious in America for such surreal antics as throwing the bathtub out of the Bonwit Teller window, was introduced to the project by his New York dealer Julien Levy. The underwater theme for the pavilion came from the promoter Billy Rose, but as Levy explained, the idea appealed to Dalí, who thought it 'a back to the womb symbol'.[41]

The theme also enabled Dalí to further explore his fascination with an architecture of corporeality – an idea he had first developed in an article of 1930 and which was followed by his more famous text, 'Concerning the Terrifying and Edible Beauty of Art Nouveau Architecture', published in *Minotaure* in 1933. The organicism and symbolism of Art Nouveau provided a model for Dalí, and in a letter to Levy of 1938 he explored the idea of a womb-like room: 'One thing I wish to build is an

intrauterine room portable, with heated saliva inside flowing down the hairy walls. When one is distressed by anything at all, one mounts this apparatus and enters in, as one would enter into the belly of the Mother.' The Dream of Venus pavilion was the nearest Dalí came to realizing his dream of a corporeal architecture.

The extraordinary plaster façade recalls the organic forms of an undersea world, with its strange coral-like branches and protrusions. The organic design must have stood in stark contrast to the sleek, streamlined architecture that dominated the Fair, particularly the startlingly geometric forms of the Trylon and Perisphere. Dalí's desire to counter the reductive aesthetics of contemporary modernist design was clearly played out in the façade.

Evocative of the 'psychic decorativism of Art Nouveau', to use Dalí's phrase, the pavilion provided a strikingly subversive statement that celebrated the fantastic and the psychologically intense. The giant figure of Botticelli's *Venus* signalled the theme of the show, but also revealed the Surrealist penchant for subverting iconic images from the history of art. An ideal of beauty, Venus is here posed next to a bizarre plaster mermaid with spotted head and stripy tail, and above a pair of giant legs through which the visitors passed into the goddess, so to speak. The sexual allusion and

Freudian implications were clear, and Venus's famous modesty belied by the almost naked real women who titillated visitors on the façade and below.

To enter the pavilion, visitors bought tickets at the bizarre fish-head booth, which with its down-turned mouth resembled the grotesque fish of traditional fountains. Passing through the gigantic legs and beneath a frilly skirt, the interior consisted of two tanks. One tank of eleven metres was filled with water and contained a series of incongruous objects, including a piano and cow against a painted backdrop of Dalían motifs, such as soft biomorphic structures and fragments of architecture. Among these elements topless

Opposite: Eric Schaal, Façade of Salvador Dalí's Dream of Venus pavilion. Photograph. 1939. Gala Salvador Dalí Foundation, Figueras

Below: Eric Schaal, Water tank in Salvador Dalí's Dream of Venus pavilion. Photograph. 1939. Gala Salvador Dalí Foundation, Figueras

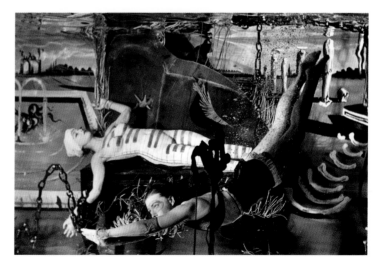

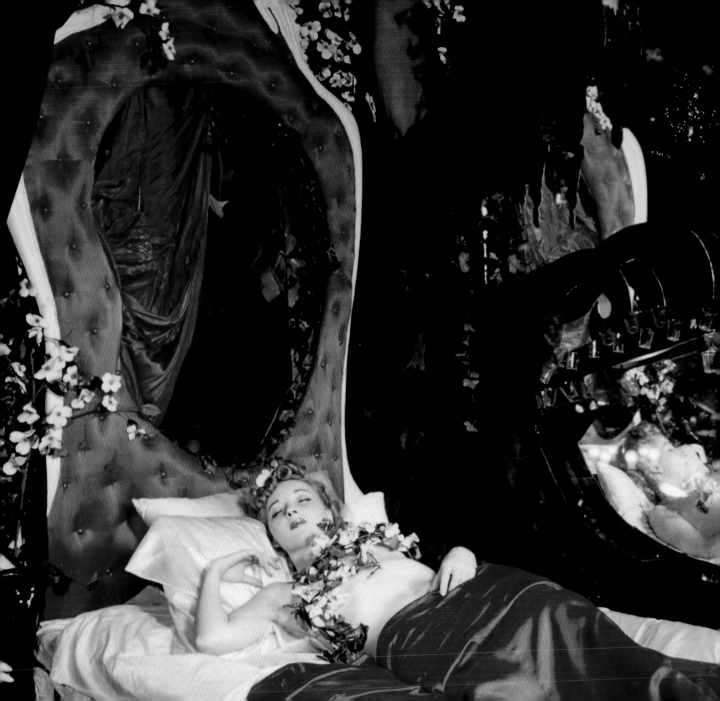

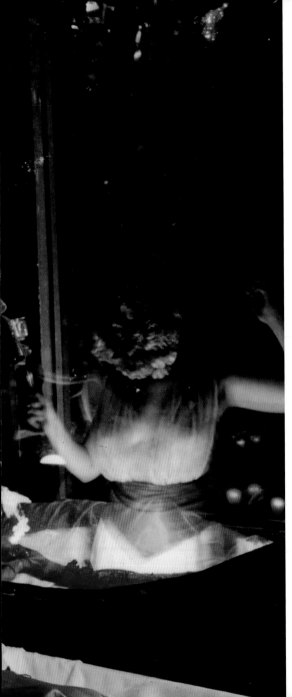

'mermaids' swam, dressed in 'little Gay Nineties girdles and fish-net stockings'.[42] The fetishistic costumes were accentuated by chains which appeared to pin the girls down. One naked model painted with piano keys lay prostrate and chained to the instrument.

The erotic imagery of the body was continued in the dry part of the interior, where a thirty-six-foot bed known as the 'Ardent Couch' revealed a topless 'Venus' asleep. Covered with red and white satin, ivy and foliage, the tableau suggested the fairytale of *Sleeping Beauty* and presumably conveyed the erotic suggestion of the kiss required to wake the beauty. Symbols of Dalí's universe surrounded the bed – a lobster, champagne and a giant telephone covered with glasses evoked the *Aphrodisiac Jacket*. The cave or womb-like space also contained various composite mannequins, including one titled the 'Aphrodisiac Vampire'. The voice of Venus could be heard over speakers saying, 'In the fever of love, I lie upon my bed. A bed eternally long, and I dream my burning dreams – the longest dreams ever dreamed without beginning and without end.'

The erotic corporeal imagery of the architecture and performance was also explored in Dalí's initial ideas for the costumes. The implicit sexual allusion in the positioning of the

Eric Schaal, Venus Dream Chamber in Salvador Dalí's Dream of Venus pavilion. Photograph 1939. Gala Salvador Dalí Foundation, Figueras

The Dream of Venus

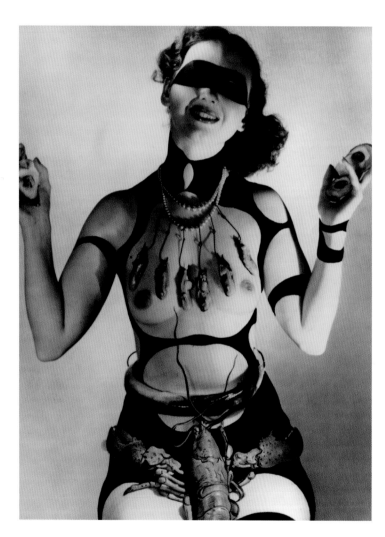

lobster on Schiaparelli's evening dress of 1938 was made explicit in Dalí's 'dressing' of the model for George Platt Lynes' photograph, where a lobster was worn as a proverbial fig leaf. In an interesting elision of the organic and the erotic, Dalí's hand emerges from the leg of the model as if inhabiting her body. Another photograph of a costume by Horst shows the model dressed in seafood with a lobster placed in her lap. Dalí often explored the slippage between objects and ideas conflating the physical and psychological, and through this process the lobster became the ultimate erotic symbol. He wrote, 'Like the lobster of the depths I am dressed in my skeleton. Within is the rose coloured flesh of dream more gentle than honey.'

Dalí's Dream of Venus pavilion objectified the real female body in a surreal experience, and in so doing ironically diminished its power to shock and disturb, which was perhaps the greatest legacy of Surrealism. The various visual strategies employed in Surrealism to intensely investigate the relationship between the corporeal and the psychological resulted in some of the most powerful conceptions of the body and images ever made. These conceptions still inform notions of the body today. After Surrealism, the body was never the same.

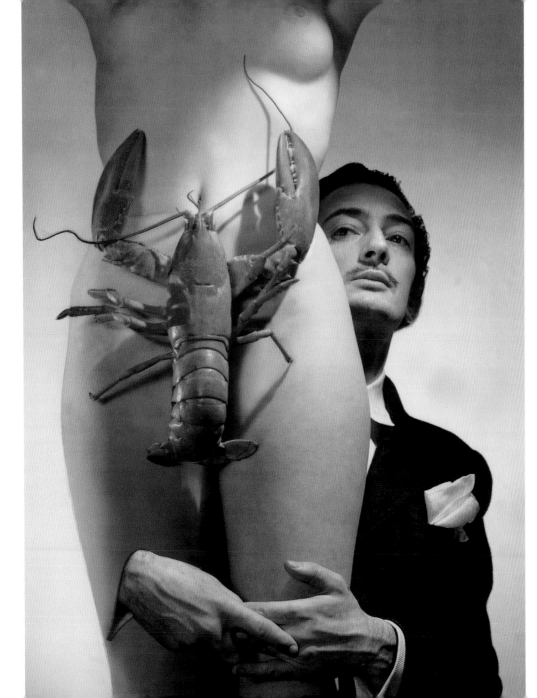

Opposite: Horst [Horst
Paul Albert Bohrmann],
Costume design for
Dream of Venus.
Photograph. 1939.
The Museum of Modern
Art, New York

Left: George Platt Lynes,
Model wearing a lobster
with Salvador Dalí.
Photograph. 1939.
The Metropolitan
Museum of Art, New York

Notes

1 Krauss, p.65

2 Jean, p. 279

3 Breton and Éluard, p.16

4 Quoted in Foster (1993), p.128; and see Krauss, 'Corpus Delicti' in *L'Amour Fou*

5 Foster (1993), p.125

6 Ibid., p.157

7 Quoted in Parrot, p.148

8 Quoted in Da Costa, p.33

9 Jean, p.280

10 Quoted in Da Costa, p.32

11 Quoted in Parrot, p.147

12 *Art et Décoration* LXVI, 1937, p.244

13 Quoted in Kachur, p.40

14 Quoted in Parrot, p.153

15 Mahon, p.44

16 Sigmund Freud, 'Fetishism', quoted in Edward D. Powers, 'These Boots Ain't Made For Walking', *Art History*, vol. 24, no. 3, June 2001, p.370

17 Jean, p.282

18 Caws, Kuenzli and Raaberg, p.2

19 Madeleine Cottenet-Hage, 'The Body Subversive: Corporeal imagery in Carrington, Prassinos and Manour' in Caws, Kuenzli and Raaberg, p.92

20 Quoted in Edward D. Powers, 'These Boots Ain't Made For Walking', *Art History*, vol. 24, no. 3, June 2001, p.369

21 I am deeply grateful to Richard Overstreet for allowing me to read the letters sent to Leonor Fini from Meret Oppenheim.

22 Quoted in Chadwick (c.1985), p.80

23 Ibid., pp.181–219

24 Agar, p.115

25 Ibid., p.168

26 K. Fijalkowski, 'Black Materialism: Surrealism faces the commercial world' in Wood, pp.101–117

27 *New York Daily*, 17 March 1939

28 Dalí (1942), p.340

29 Flügel, pp.26–27

30 Dalí (1942), p.340

31 Mendes, p.41

32 The double profile may represent Tristan and Isolde. See Blum, p.124. Salvador Dalí used a similar double image for his Tristan and Isolde brooch of 1953.

33 Another example of this evening coat is in the collections of the Philadelphia Museum of Art. The designs of the two differ slightly: in the Philadelphia version the appliqué roses are more profuse, covering the shoulders, the collar is lower and the column motif has four flutes rather than the five in the V&A's example. The shape of the back panel may also differ.

34 Letter of March 1970 from Edward James to Carol Hogben, V&A file on Mae West Lips Sofa

35 Elizabeth Ann Coleman, *The Genius of Charles James* (New York, 1982), p.23

36 Dalí (1975), unpaginated

37 Twenty-one of the Alemany works were bought by the millionaire Cummins Catherwood, and later formed the basis of the Owen Cheatham Foundation collection which toured widely from the late 1950s and helped cement Dalí's reputation as the pre-eminent Surrealist artist. See *Dalí Jewels* and Eidelberg (ed.), catalogue entry for *Persistence of Memory*

38 The number of pieces made by Alemany is unknown as they seem to have made editions of certain pieces. The shop of the St Regis hotel in New York sold examples of Dalí jewels made by Alemany. However, many unique works entered the Owen Cheatham collection and several were mechanized.

39 Livingston, p.36

40 A starfish appears in the painting *The Rhinocerotic Disintegration of Illissus of Phidias* (1954), amongst other works.

41 Levy, pp.213–214

42 Quoted in Kachur, p.140

Further Reading

Journals

Art et Décoration: Revue mensuelle d'art moderne (Paris, 1897–)

Harper's Bazaar (New York, 1867–)

Femina (Paris, 1901–38, 1945–54)

Minotaure, revue artistique et littéraire (Paris). Albert Skira, E. Tériade (eds), Albert Skira (publisher), nos 1–13, June 1933–May 1939

Vogue (Paris, 1892– ; London, 1916– ; New York, 1892–)

Primary Texts

Agar, E., *A Look At My Life*, in collaboration with Andrew Lambirth (London, 1988)

Apollinaire, G., *Apollinaire on Art: Essays and Reviews*, 1902–1918, ed. Leroy C. Breunig, trans. Susan Suleiman (New York, 1988)

Aragon, L., *Paris Peasant* (1926), trans. and introduction by Simon Watson Taylor (Boston, 1994)

Breton, A. and Éluard, P., *Dictionnaire Abrégé du Surréalisme* (Paris, 1938)

Breton, A., *Manifesto of Surrealism* (1924), trans. Richard Seaver and Helen R. Lane (Ann Arbor, [1969], 1972)

Breton, A., *Nadja* (1928), trans. Richard Howard and introduction by Mark Polizzotti (London, 1999)

Breton, A., *Mad Love* (*L'Amour Fou*) (1937), trans. Mary Ann Caws (Lincoln and London, 1987)

Dalí, Salvador, *The Secret Life of Salvador Dalí*, trans. Haakon M. Chevalier (New York, [1942], 1993)

Dalí, Salvador, *Eroticism in Clothing*, trans. Mmes Gala Dalí and Eleanor R. Morse, together with Mr Dalí and Mr Morse (Figueras, 1975)

Flügel, J.C., *The Psychology of Clothes* (London, 1930)

Freud, S., *The Standard Edition of the Complete Psychological Works of Sigmund Freud*, ed. and trans. James Strachey, Vols I–XXIII (London, 1950–2001)

Jean, M., *The History of Surrealist Painting* (1959), trans. Simon Watson Taylor (London, 1960)

Lautréamont, Comte de (Isidore Lucien Ducasse), *Les Chants de Maldoror*, illustrations by Salvador Dalí (Paris, 1934)

Levy, J., *Memoir of an Art Gallery* (New York, 1977)

Von Sacher-Masoch, L.R., *Venus in Furs* (New York, 1947)

Secondary Texts

Ades, D. (ed.), *Dalí: the Centenary Retrospective* (London, 2004)

Adler, K. and Pointon, M. (eds), *The Body Imaged: The Human Form and Visual Culture Since the Renaissance* (Cambridge, c.1993)

Blum, D., *Shocking! The Art and Fashion of Elsa Schiaparelli* (exhib. cat.) (Philadelphia Museum of Art, New Haven and London, 2003)

Caws, M.A., Kuenzli, R.E. and Raaberg, G. (eds), *Surrealism and Women* (Cambridge, Mass. and London, 1991)

Caws, M.A. (ed.), *Surrealism* (London, 2004)

Chadwick, W., *Women Artists and the Surrealist Movement* (London, c.1985)

Chadwick, W. (ed.), *Mirror Images: Women, Surrealism and Self-Representation* (Cambridge, Mass. and London, 1998)

Coleman, E.A., *The Genius of Charles James* (exhib. cat.) (New York, 1982)

Da Costa, V., *Robert Couturier* (Paris, 2000)

Dalí Jewels, The Collection of the Gala-Salvador Dalí Foundation (Figueras, 2001)

Durozoi, G., *History of the Surrealist Movement* (London, 2002)

Eidelberg, M.P. (ed.), *Design 1935–1965: What Modern Was: Selections from the Liliane and David M. Stewart Collection* (exhib. cat.) (Montreal, 1991)

Evans, C. and Thornton, M., *Women and Fashion: a New Look* (London, 1989)

Foster, H. (ed.), *Damaged Goods: Desire and the Economy of the Object* (exhib. cat.) (New York, 1986)

Foster, H., *Compulsive Beauty* (Cambridge, Mass. and London, 1993)

Kachur, L., *Displaying the Marvelous: Marcel Duchamp, Salvador Dalí, and Surrealist Exhibition Installations* (Cambridge, Mass. and London, c.2001)

Krauss, R. and Livingston, J., *L'Amour Fou: Photography & Surrealism* (exhib. cat.) (Washington DC, 1985)

Lichtenstein, T., *Behind Closed Doors, The Art of Hans Bellmer* (Berkeley, London, New York, 2001)

Livingston, L. (ed.), *Dalí: A study of his art-in-jewels: the collection of the Owen Cheatham Foundation* (Greenwich, Conn., 1959)

Lomas, D., *The Haunted Self: Surrealism, Psychoanalysis, Subjectivity* (New Haven and London, 2000)

Mahon, A., *Surrealism and the Politics of Eros 1939–1968* (London and New York, 2005)

Martin, R., *Fashion and Surrealism* (New York, 1987)

Mendes, V.D., *Black in Fashion* (London, 1999)

Mundy, J. (ed.), *Surrealism. Desire Unbound* (exhib. cat.) (London, 2001)

Nesbit, M., *Atget's Seven Albums* (Yale, New Haven and London, 1992)

Parrot, N., *Mannequins* (London, 1983)

Richardson, M. and Fijalkowski, K. (eds), *Surrealism Against the Current: Tracts and Declarations* (London, 2001)

Rosemont, P. (ed.), *Surrealist Women: An International Anthology* (Austin, 1998)

Salvador Dalí Dream of Venus (exhib. cat.) (Barcelona, 2000)

Sawin, M., *Surrealism in Exile and the Beginning of the New York School* (Cambridge, Mass. and London, 1995)

Schaffner, I., *Salvador Dalí's Dream of Venus: The Surrealist Funhouse From the 1939 World's Fair* (New York, 2002)

Spiteri, R. and LaCoss, D. (eds), *Surrealism, Politics and Culture* (Aldershot, 2003)

Taylor, S., *Hans Bellmer: The Anatomy of Anxiety* (Cambridge, Mass., c.2000)

Wood, G. (ed.), *Surreal Things: Surrealism and Design* (exhib. cat.) (London, 2007)

Index

Page numbers in *italic* refer to illustration captions

Agar, Eileen 51–3
 Ceremonial Hat for Eating Bouillabaisse 51–3, *53*
 Glove Hat 53, *53*
Aillaud, Emile 18
Alemany, Carlos B. 82
Alix 23
Apollinaire, Guillaume 9, 10
Aragon, Louis 68
 Le Paysan de Paris 56
Atget, Eugène 56
 Boulevard de Strasbourg (Corsets) 59

Bayer, Herbert, self-portrait 15
Beaux-Arts, Galerie, Paris 26
Bellmer, Hans 6
 Les jeux de la poupée 9
 La Poupée (The Doll) 12, *13*, 17
Bergery, Bettina 60
Bonwit Teller, Fifth Avenue, New York, shop window 58–60, *59*, 86
Brauner, Victor, *L'Objet qui rêve II* 41
Breitenbach, Joseph, *Rue Surréaliste* 27
Brentano's, New York 56–8
Breton, André 10, 47
 L'Amour Fou 42
 Arcane 17 56–8
 Nadja 42
 Surrealism and Painting 56
Buñuel, Luis 36

Cahun, Claude
 self-portrait *15*
 shop window with shoes *59*
Carrington, Leonora 68
Un Chien Andalou 36
Chirico, Giorgio de 10
 Le Duo (les mannequins de la tour rose) *11*, 12
Cocteau, Jean, designs with Schiaparelli 65–8
Couturier, Robert 18–21
 mannequins *21*, *24*
Crevel, René, *Dictionnaire abrégé du surréalisme* 10

Dalí, Salvador 36, 53, 60, 64, 68, 80, 90
 Aphrodisiac Jacket 89
 Bonwit Teller shop window 58–60, *59*, 86
 'Concerning the Terrifying and Edible Beauty of Art Nouveau Architecture' 86
 Cover design for *Minotaure 41*
 Dream of Venus pavilion, World's Fair, New York 86–90
 Eroticism in Clothing 81
 'Etoile de Mer' brooch 82–5, *85*
 jewels of 82–5
 leaf-veined case 83
 Mae West Lips sofas 73
 mannequin dressed by *27*
 The Persistence of Memory 82
 Retrospective Bust of a Woman 16, *17*
 Ruby Lips brooch 82, *83*
 'Skeleton' dress, design drawing 63
 telephone ear clips *83*
 Three Young Surrealist Women Holding in Their Arms the Skins of an Orchestra 65, *67*
 Venus with Drawers 38, *39*
 see also Schiaparelli, Elsa

Dohmen, Leo, *L'Ambitieuse 35*
Dominguez, Oscar *31*, 38
Donati, Enrico, and Duchamp, Marcel, Gotham Book Mart, shop window 56, *59*
Drouin, Galerie, Paris 51
Duchamp, Marcel 56–8
 mannequin 29, *29*
 see also Donati, Enrico

Ernst, Max 68
Ertman, Eric 82
Exposition Internationale des Arts et Techniques dans la Vie Moderne de Paris, Pavillon de l'Élégance 18–24
Exposition Internationale du Surréalisme 26–31
Exposition Surréaliste d'Objets 45

Fantastic Dada and Surrealism exhibition, Museum of Modern Art 58
Femina 24
Fini, Leonor 47–51, *47*, 68
 L'Architecture 48, 51
 Armoire anthropomorphe 47, *48*, 51
 corset chair *51*
 La Peinture 48, 51
Flügel, J.C., *The Psychology of Clothes* 62–4
Frank, Jean Michel 60
Freud, Sigmund 10, 12, 32, 38, 62, 64, 87

Giacometti, Alberto 68

Harkness, Rebecca 82, 85
Harper's Bazaar 24

Harper's Bazaar (American) 67
Hoffmann, E.T.A., 'The Sandman' 12
Horst (Horst Paul Albert Bohrmann)
 Barefoot Beauty 35
 costume design for Dream of Venus *91*
 Girl with Mainbocher corset 37
Houdon, Jean-Antoine, bust of Madame Dubarry 17
Hugnet, Georges 26, 36
Huysmans, Joris Karl, *Croquis Parisiens* 12–17

Isay, Raymond 18

James, Charles 77–80
 coat *79*
 evening jacket 77–80, *79*
 'Sirène' evening dress 80, *81*
James, Edward 60, 73
Jean, Marcel 18, 36
 Le spectre du gardénia 17, *17*

Kohlmann, Etienne 18

Lanvin, Jeanne *21*, 23
Lautréamont, Comte de (Isidore Ducasse), *Les Chants de Maldoror* 38, 65
Lesage 69
Les Lettres Françaises 21
Levy, Julien 86
London Bystander 18

Maar, Dora 45
 untitled photograph *37*

Magritte, René
 The False Mirror 35, 36
 Love Disarmed 73

Manet, Edouard, *Le Déjeuner sur l'Herbe 47*

Man Ray *26–9, 38, 64, 68, 73*
 coat stand *11*
 Larmes (Tears) *35*
 portrait of Meret Oppenheim *43*
 La Volière 13

Masson, André, mannequin *29, 29*

Minotaur *38*

Minotaure 12, 41, 64

Museum of Modern Art, New York *58*

Nash, Paul *51*

Oppenheim, Meret *45–51, 68*
 fur bracelet *45, 45*
 Objet (Le déjeuner en fourrure) 45–7, 45
 project for sandals *45, 47*

Parry, Roger, untitled photograph *35, 36*

Pascale *59, 60*

Pascaline *60*

Peruglia, André *73*

Picasso, Pablo *45, 73*

Platt Lynes, George, model wearing a lobster with Salvador Dalí *90, 91*

Ratton, Charles, Galerie, Paris *45*

La Revue des Deux Mondes 18

Sacher-Masoch, Leopold von, *Venus in Furs 38, 47*

Schiaparelli, Elsa *9, 21, 23, 39, 45, 60, 64–77*
 'Column' dress *69*
 decorative elements from clothes and accessories *73*
 'Etruscan' dress *69*
 evening coat (with Jean Cocteau) *69*
 evening gloves *71*
 gloves *53*
 gloves with fingernails *73, 75*
 gold coat *9*
 hat with insects *71*
 lamb chop jacket *73, 73*
 lobster evening dress *90*
 monkey fur coat *41*
 pine cone necklace *75*
 Place Vendôme shop
 display of 'Sleeping' perfume *69*
 Pascale in the perfume boutique *69*
 rose bib necklace *77*
 'Shoe' hat (with Dalí) *63, 65*
 'Skeleton' evening dress *63, 65, 65*
 'Spine' evening dress *80–81, 81*
 suede and monkey fur boots *77*
 'Tear' dress *65, 67*
 veil with gold snail shell *65, 65*
 velvet evening dress *9*
 waltz-length evening dress *71*

Schaal, Eric
 Dream of Venus pavilion *87*
 Venus Dream Chamber *89*

Seligmann, Kurt *31, 36*

Tanning, Dorothea
 Nue Couchée 53, 55
 Rainy Day Canapé 53

Toyen (Marie Cermínová), screen *43, 45*

Triolet, Elsa *68*

Tzara, Tristan, 'On a Certain Automatism of Taste' *64*

Ubac, Raoul *6*
 mannequins
 dressed by André Masson *29*
 dressed by Marcel Duchamp *29*
 dressed by Oscar Dominguez *31*
 dressed by Kurt Seligmann *31*
 Penthésilée 9

Verdura, Fulco di *82*

Vibert, Max *18*

Vogue 24

West, Mae *82*

Wols (Alfred Otto Wolfgang Schulze) *23–4*
 Exposition Internationale des Arts et Techniques dans la Vie Moderne de Paris, Pavillon de l'Élégance 19, 21
 Hands 24
 Mannequin by Robert Couturier for Alix 24
 Mannequins by Robert Couturier for Lanvin 21
 Mannequin by Robert Couturier for Schiaparelli 21

World's Fair, New York, Dream of Venus pavilion *86–90*

Zahar, Marcel *24*

Picture Credits

Images and copyright clearance have been kindly supplied as listed below

© ADAGP, Paris and DACS, London 2006: 6, 7, 13, 17, 18, 21, 22, 23, 28, 29, 47, 48, 49; © ADAGP, Paris and DACS, London 2006. Collection Museum of Contemporary Art, Chicago, gift of Joseph and Jory Shapiro Fund: 41; © ADAGP, Paris and DACS, London 2006. Foto: Herbert Boswank: 19, 24, 25; © ADAGP, Paris and DACS, London 2006 © Photo CNAC/MNAM Dist. RMN/ © Jacques Faujour: 37; © ADAGP, Paris and DACS, London 2006. Photo: Florent Dumas: 50; © ADAGP, Paris and DACS, London 2006 © PMVP/Joffre: 30, 31, 43; © ADAGP, Paris and DACS, London 2006. Purchase. 133.1936 © 2006. Digital image, The Museum of Modern Art, New York/Scala, Florence: 35; © ARS, NY and DACS, London 2006: 86, 87, 88; © DACS 2006: 14, 44, 45a, 45b; © DACS 2006. James Thrall Soby Bequest. Acc. no.: 1213.1979 © 2006. Digital image, The Museum of Modern Art, New York/Scala, Florence: 10; © Estate of George Platt Lynes. The Metropolitan Museum of Art, David Hunter McAlpin Fund, 1941 (41.65.28) Photograph © 1999 The Metropolitan Museum of Art: 91; © Horst P. Horst/Art + Commerce: 36, 37b, 90; © Man Ray Trust/ADAGP, Paris and DACS, London 2006: 11, 12, 33, 42; The Metropolitan Museum of Art, Ford Motor Company Collection, Gift of Ford Motor Company and John C. Waddell, 1987 (1987.1100.144): 34; © Photo CNAC/MNAM Dist. RMN/© Georges Meguerditchian: 58; Photograph by Irving Solero, courtesy of the Museum at the Fashion Institute of Technology, New York: 81; © Salvador Dali, Gala-Salvador Dali Foundation, DACS, London 2006: 27, 39, 41, 59, 63, 66, 82, 83a, 83b, 84, 85; © Salvador Dali, Gala-Salvador Dali Foundation, DACS, London 2006. Acquired through the Lillie P. Bliss Bequest and gift of Philip Johnson (by exchange). 301.1992 © 2006. Digital image, The Museum of Modern Art, New York/Scala, Florence: 16; © Succession Marcel Duchamp/ADAGP, Paris and DACS, London 2006. Philadelphia Museum of Art: Gift of Jacqueline, Peter and Paul Matisse in memory of their mother, Alexina Duchamp: 57